ANTALYA
TURKEY'S SOUTHERN COAST

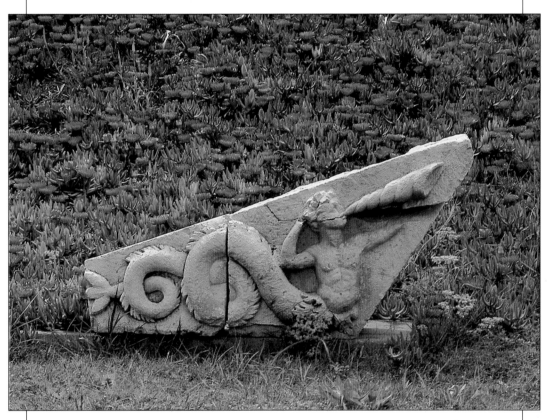

R E V A Ş
REHBER BASIM YAYIN DAĞITIM
REKLAMCILIK VE TİCARET A.Ş.

REVAK

ANTALYA
TURKEY'S SOUTHERN COAST

Published and Distributed by
**REVAŞ Rehber Basım Yayın Dağıtım
Reklamcılık ve Tic. A.Ş.**

Translation :
Adair Mill

Photos :
Erdal Yazıcı, Güngör Özsoy, Halûk Özözlü,
Firdevs Sayılan, Dönence Diabank.

Layout :
Kemal Özdemir

Typsetting:
AS & 64 Ltd. Şti

Colour Separation and Printed Turkey by
Çali Grafik Matbaacılık A.Ş.

© Copyright 1998 by Rehber Basım Yayın Dağıtım A.Ş.

ISBN 975-8212-31-1

REVAŞ
REHBER BASIM YAYIN DAĞITIM
REKLAMCILIK VE TİCARET A.Ş.

İnönü Mahallesi, Ölçek Sokak No: 172-174,
Harbiye, İstanbul - TÜRKİYE
Tel: (90-212) 240 72 84 - 240 58 05
Fax: (90-212) 231 33 50

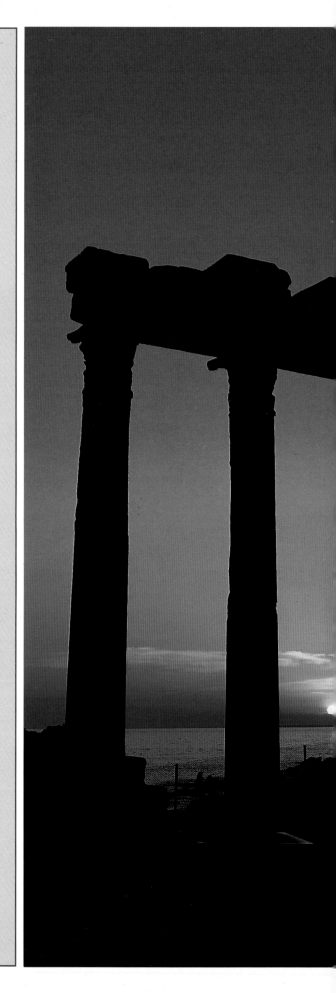

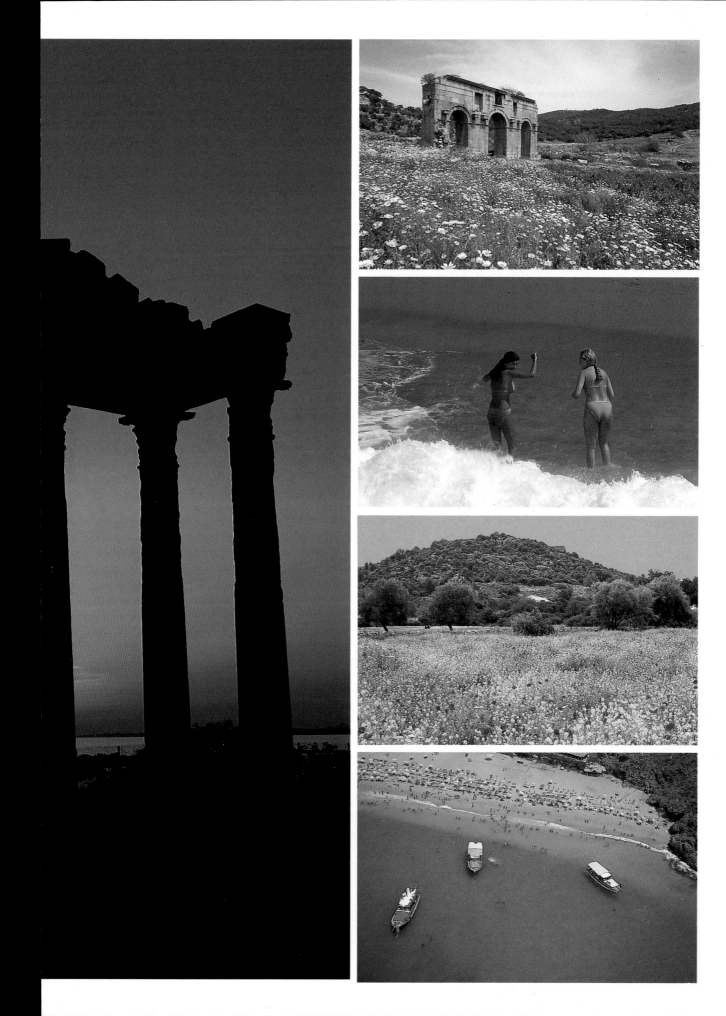

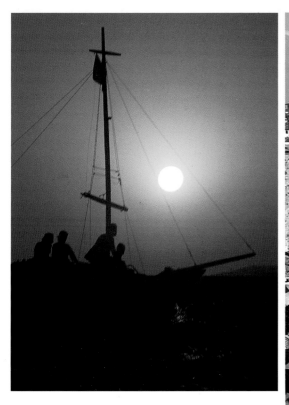

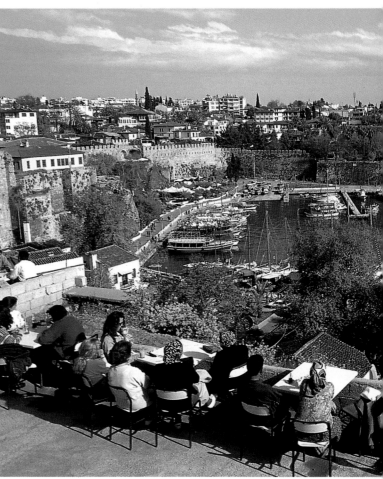

INTRODUCTION

Welcome to Turkey, and welcome to Antalya, one of the loveliest province in a country, in which, every provinces are more beautiful and more interesting than the others. Welcome to Turkey's southern coast and its Mediteranean shores!

Modern geographers are now abandoning the old conventional geographical definitions and replacing them with new definitions more in tune with the newly developing facts and concepts based upon them. One of the innovations steadily winning general acceptance is the abandonment of the old concept of the "continent" for a definition of new groupings on the basis of "human geography". Those who adopt this approach base their theses on the concepts of "Mediterranean" and the "Mediterranean people", taking the Mediterranean basin as an example of the new concept of "continent". Indeed, taken as a whole, the countries surrounding the Mediterranean basin and

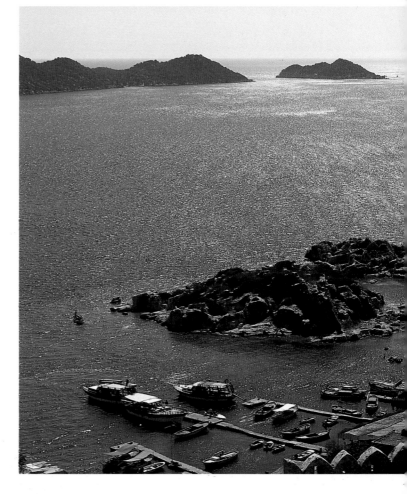

Sunset at Kaş.
Yacht Marina, Antalya.

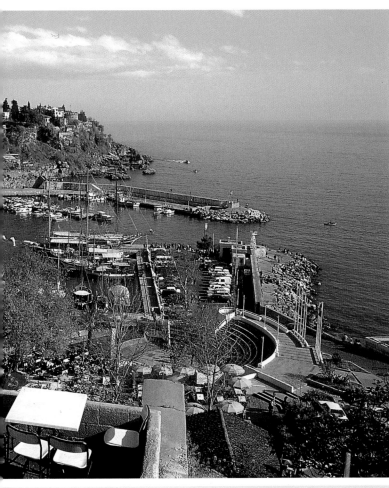

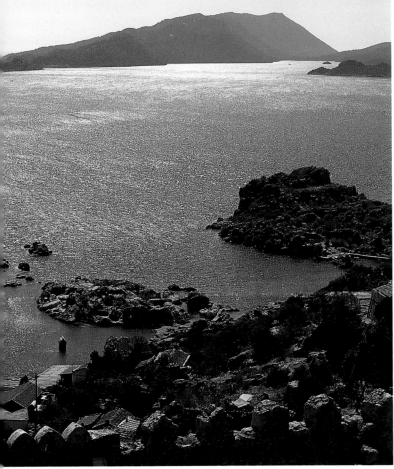

the people living in them, with all their peculiar characteristics and rich history, have much more in common than most of the conventional "continents".

The Mediterranean region is not only unique in its characteristics mentioned above but, it also possesses natural and historical treasures of wealth and variety to be found in no other corner of our old planet. And one of the most beautiful corners in the Mediterranean region is undoubtedly the shores and environs of Antalya. So we welcome you to this extraordinarily beautiful, extraordinarily fascinating province! This book concentrates on the province of Pamphylia, right in the middle of which stands the modern city of Antalya, but as the whole region, with its ancient settlements, sites and ruins, is intimately connected with the ancient province of Lycia on the west, we have decided to include this province in our book in order to give a more comprehensive survey of the region as a whole.

A beautiful bay where blue and green meet.
Kekova National Park, general view.

GEOGRAPHICAL LOCATION AND LOCAL HISTORY

A glance at a map of the region cannot fail to remind one of the great Turkish poet Nazım Hikmet's description of Anatolia as a peninsula projecting like a horse's head from Asia into the Mediterranean, with the Taurus Mts. running along the south coast parallel to the sea. As we make our way inland from Çukurova plain in the province of Adana, we arrive to the mountains known as the Anti-Taurus.

This range, with an average height of 2000 m and individual peaks as high as 3000 m, separates the Central Anatolian plateau, with an average altitude of 1000 m, from the coastal plain. Covered deep in snow during the winter months, these mountains give rise to the hundreds of streams, large and small, that water sometimes very narrow to coastal strip, where a combination of Mediterranean sunshine and fertile soil produce areas of very great fertility.

As we ascend the mountain slopes we pass through dense forests of cluster pine with cedars on the higher reaches. Above 2000 m the mountains are completely devoid of vegetation. These mountains are a hunter's paradise, with a very rich fauna, the most popular species being the wild goat. We learn from various historians of the large numbers of panthers that used to live in this area, but the species is now extinct.

The province known in ancient times as Pamphylia consists of a fertile plain between the sea and the Taurus Mts 25-30 km in width, extending from the bay of Antalya in the west to the Manavgat (Melas) river 75 km to the east. This extremely fertile plain, watered by the streams of the Aksu (Cestros), Köprüpazarı (Eurymedon) and Manavgat

Yacht Marina, Antalya.

A view of Perge.

Apollon Temple, Side.

Adrasan, breathtaking coasts of Antalya.

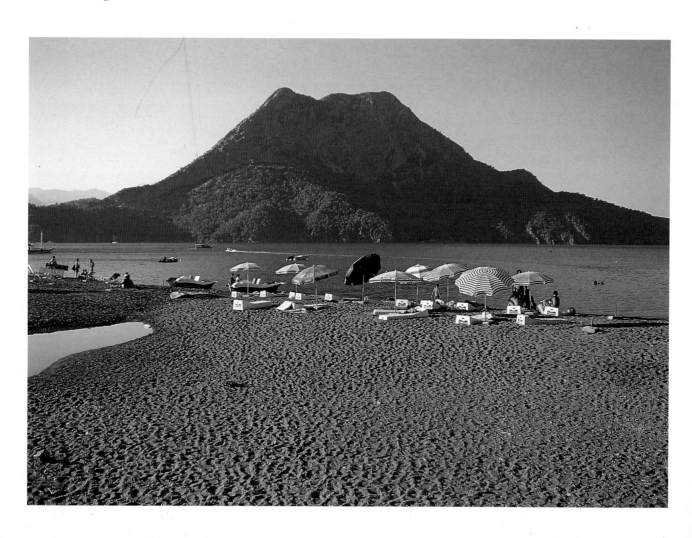

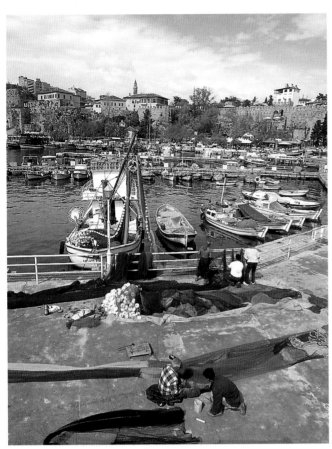

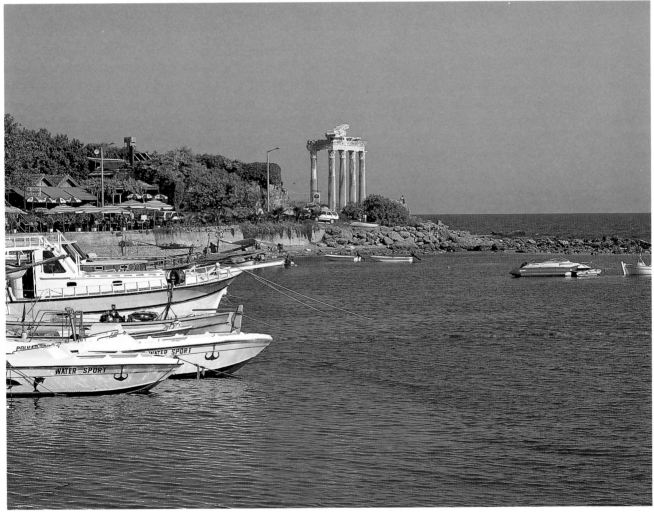

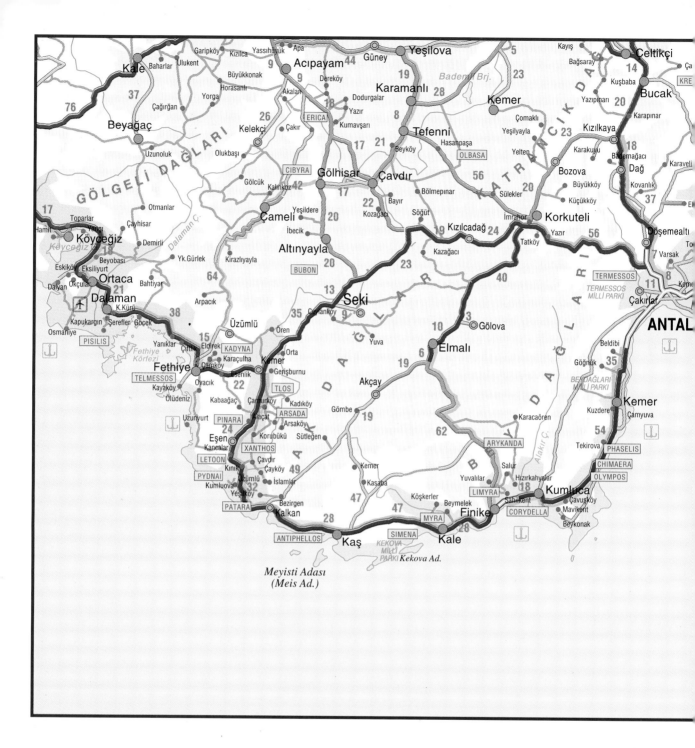

(Melas), is the main vegetable producing area of modern Turkey. The most important products of the area are cotton and cereals, together with sesame and citrous fruits, while in recent years there has been also a significant increase in the trade of cut flowers. Greenhouses allow a specialisation in the early development of fruit and vegetables. The extraordinary fertility resulting from the combination of a rich soil, a plentiful water supply and the Mediterranean sun, has been a source of attraction for many people throughout the centuries, leading to the foundation of rich and imposing cities. Indeed, the region can boast the finest theatres, aqueducts and cities in the whole of Anatolia.

The Karain cavern contains the earliest vestiges of human habitation in Pamphylia, dating back to 100,000 B.C. Pamphylia thus carries great importance

Map of Antalya and surroundings.

8

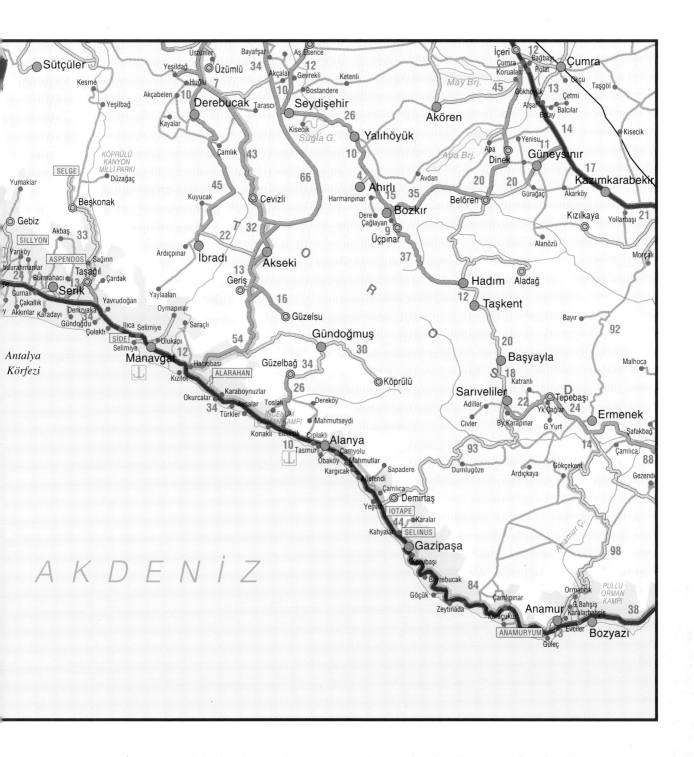

as one of the localities where men made their first appearances on this old planet, and the caverns and rock shelters to be found along the boundary between the Taurus Mts. and the plain were extensively used by the first inhabitants of the region. In the Neolithic age, which followed the Paleolithic and Mezolithic periods, men began to descend to the plains below, and in the Bronze Age, as a result of the increase in population and the development of trade, the region rapidly attained a certain importance. After the Trojan War, which took place towards the end of the 2nd millennium and was related with such power and beauty by Homer, a native of Izmir, in the Iliad and the Odyssey, several people came and settled in Pamphylia, where, they, anxious to provide for their own defence and security, founded their first city. The most famous of these cities,

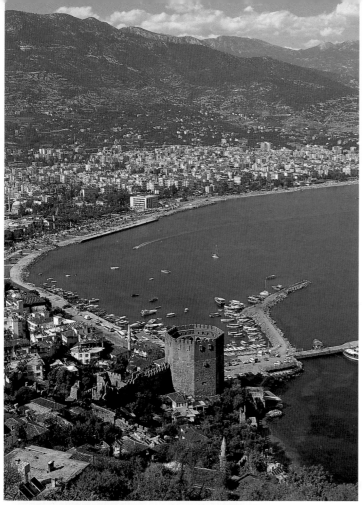

from west to east, were Antalya (Attaleia), Perge, Sillyon, Aspendos and Side. Although Selge, hidden away in the depths of the Beşkonaklar valley, was actually a Pisidian city, the Köprüpazarı (Eurymedon) permitted close connections with Pamphylia. This valley, an area of extraordinary beauty praised for the wealth of its flora, is now preserved as a National Park.

These colonies lost their independence and importance following their subjection to Persian rule in 546 B.C., and although the strong naval base established by the Persians on the Eurymedon was captured in 467 B.C. by the Athenian commander Cimon with a fleet of 200 ships, the Persians later succeeded in reconquering the region, with the result that Persian hegemony was to continue until the arrival of Alexander the Great in 334 B.C. All the

Alanya, a typical view of Kaş
Antalya Konyaaltı Beach, Simena.

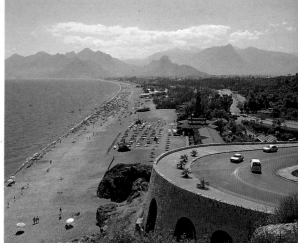

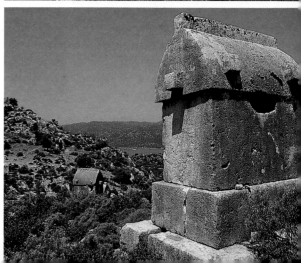

Pamphylian cities, led by Perge, warmly welcomed and supported the great Macedonian conqueror, who used the area as a base for refurbishment and reinforcement before proceeding to further conquests.

Following Alexander's death in 323 B.C., Pamphylia, like a large part of Anatolia, changed hands several times between the Seleucids and the Kingdom of Pergamon, finally becoming incorporated under the Kingdom of Pergamon by the Treaty of Apameia in 188 B.C. With the death of Attalus III in 133 B.C. Pamphylia, along with Pergamon, came under the hegemony of Rome in accordance with the terms of Attalus' will, thus entering the 'Pax Romana' and the most brilliant period of its existence. At that time the Roman Empire was at the height of its power, road communications were steadily

Antalya Harbour, Kekova,
Vacation villages from Eastern Antalya.

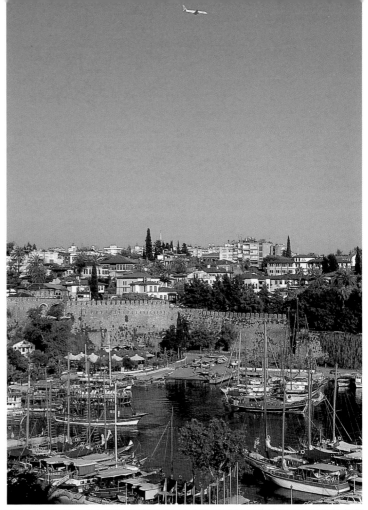

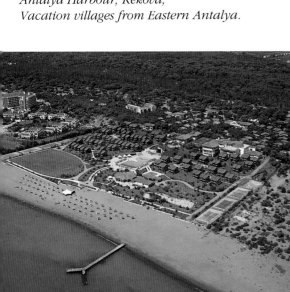

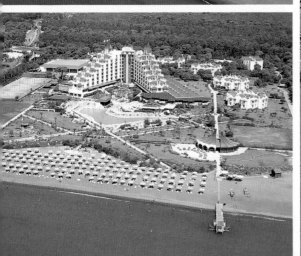

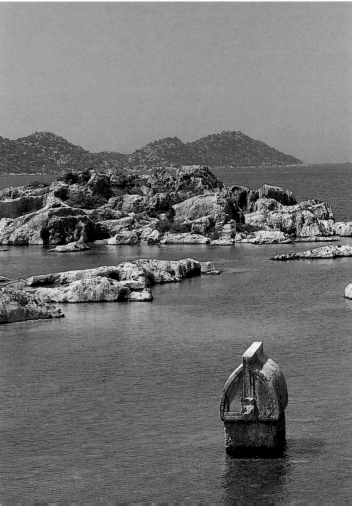

developed throughout Anatolia, and peace and prosperity reigned. This gave rise to a great increase in the wealth and population of the cities accompanied by extensive building programmes, with new defence walls, theatres, bath-houses, agoras, fountains and other monumental edifices. There was also an extraordinary development in the fine arts, with every city vying with the others in the beauty of its columns, statues and busts. The great damage caused by earthquakes in the 1st and 2nd centuries was repaired under powerful emperors such as Trajan, Hadrian, Marcus Aurelius and Septimius Severus, and the cities restored to their former magnificence.

Under Constantine the Great (324-337) Christianity became the established religion in Pamphylia, as in the rest of the Roman Empire, and the following period saw the construction of imposing church buildings throughout the province. However, with the rise of Islam and the foundation of powerful Arab states,

Different scenes from Antalya shores.

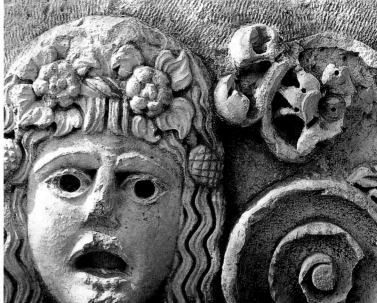

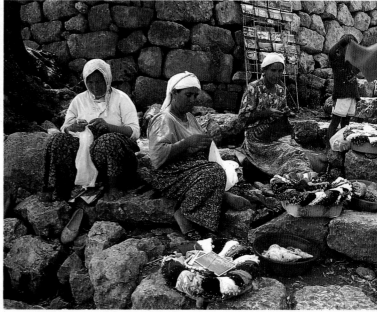

Pamphylia became exposed to raids of steadily increasing intensity in the 7th and 8th centuries as well as to the attacks made by the increasing number of pirates in the Mediterranean. All this led to urban decline and the breakdown of existing socio-economic systems, with the result that when the cities were destroyed by an exceptionally severe earthquake towards the end of the 8th century no revival was possible.

The Turks first made their appearances on the eastern frontiers of Anatolia at the beginning of the 11th century, and, after the crushing defeat inflicted on the Byzantine Emperor Romanus Diogenes at the battle of Malazgirt in 1071, the Seljuk Turks rapidly spread throughout the whole of Anatolia, establishing their capital at Konya. At the beginning of the 13th century (1207) the province of Pamphylia was incorporated under the Turkish state.

Different scenes from Antalya shores.

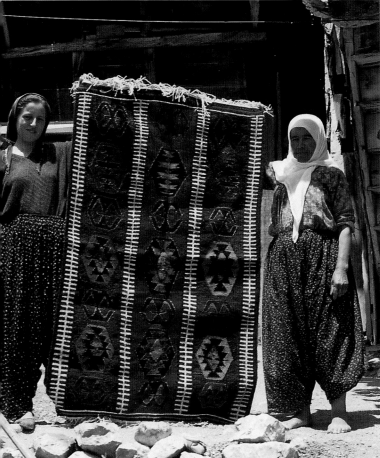

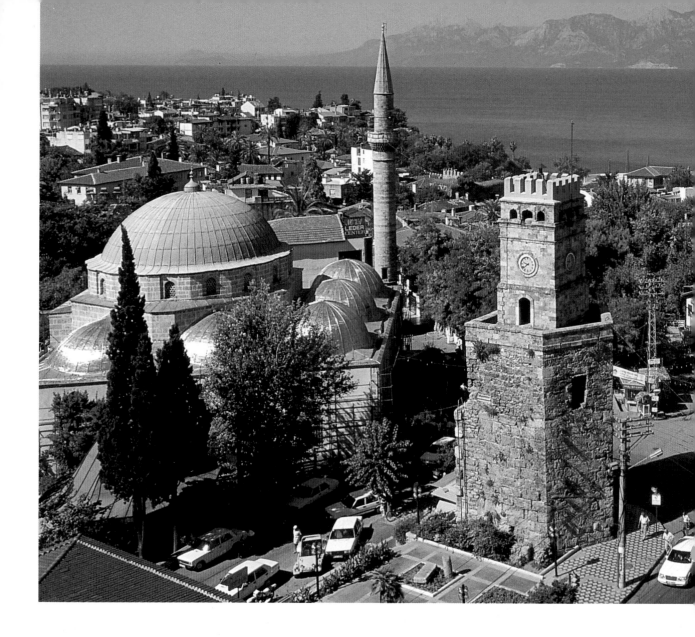

A N T A L Y A

In recent years, the gulf of Antalya, with a coastal strip of some 200 km with bays and coves of exceptional beauty filled with the crystal clear waters of the Mediterranean, has become one of the most popular tourist resorts in Turkey. The coastal plain is covered with banana plantations and orchards of citrous fruit, as well as pine forests and groves of palm trees.

The peaks of the Taurus mountains, from which tall trees descend in places right down to the shore, remain covered in snow right up until the middle of summer. Antalya itself, as well as the nearby tourist centres of Kemer, Beldibi, Belek, Side and Alanya, are thronged with tourists througout every season of the year.

The coves, valleys and forests in the vicinity offer picnic sites of extraordinary beauty. Besides the ancient cities, there are waterfalls and caverns and many other natural beauties waiting to greet the visitor.

The city of Antalya is situated on cliffs at the extreme end of the gulf. The city centre is located in the region contained within the old defence walls surrounding the yacht harbour, but, since the 1970s and 1980s, the city has expanded very

A panoramic view of Antalya.

Antalya, Old Town and Yacht Marina.

Antalya, Lara shores.

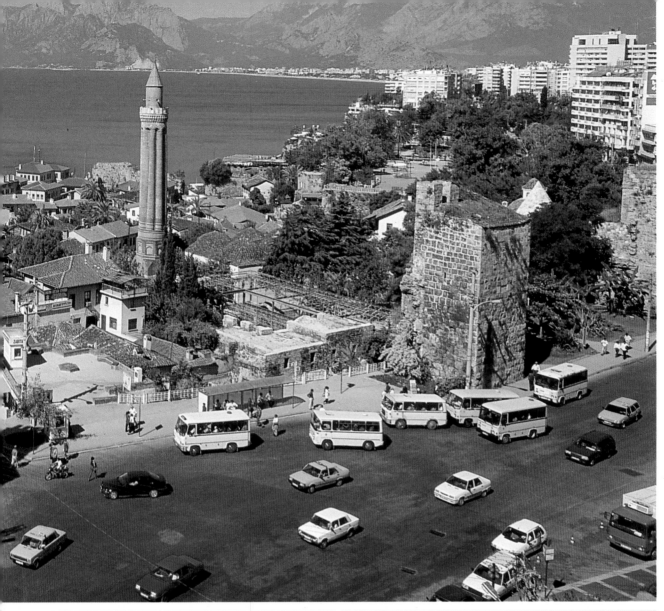

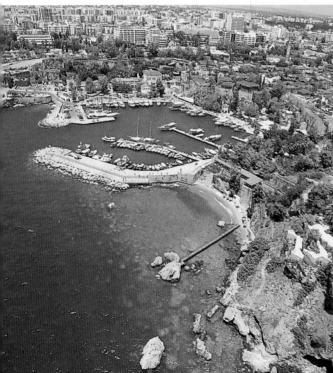

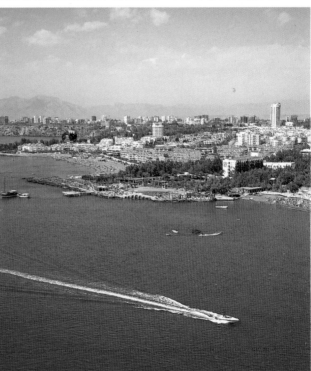

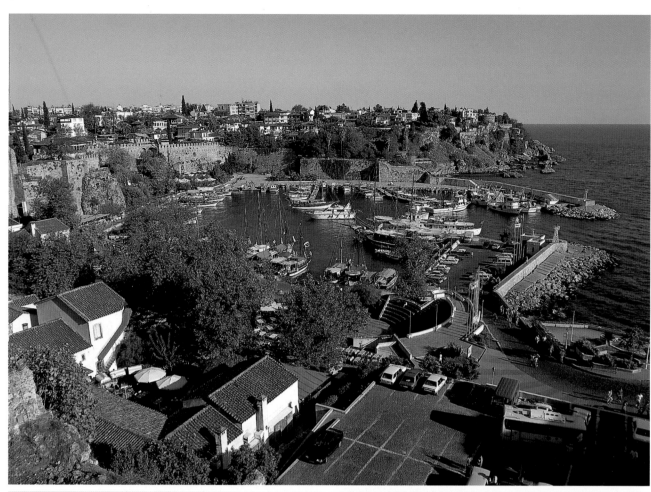

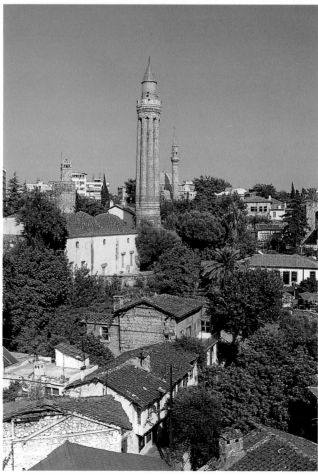

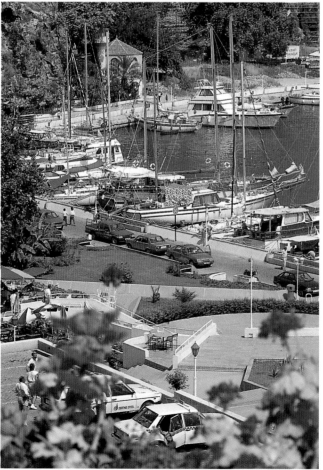

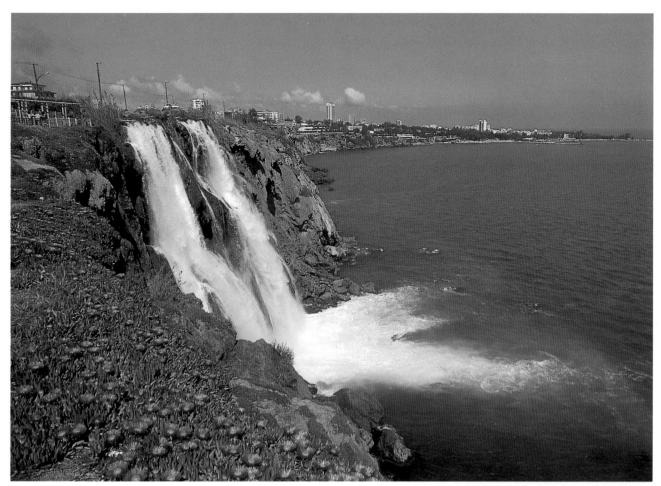

Antalya Narenciye Waterfalls.

Antalya Old Town, Hıdırlık Tower.

Antalya, Yacht Marina.

Antalya, Yivli Minare.

A typical view from the Harbour.

rapidly towards the west and north. In the last twenty years, immigration from central and eastern Anatolia has raised the urban population by some 400%.

The production of cotton on the fertile soil, the huge greenhouses and, of course, tourism all contribute to local wealth and prosperity. Antalya also contains a number of summer-houses owned by residents in other parts of Turkey.

Although the surrounding region has been inhabited for nearly 50,000 years, the centre of the province of Antalya is a fairly recent settlement.

While the other ancient cities in the vicinity date back as far as 1000 B.C., Antalya was founded in the 2nd century A.D. by Attalus, King of Pergamon, who named the city 'Attaleia'.

The ancient city, whose main source of income were the trade in salt, olive oil.

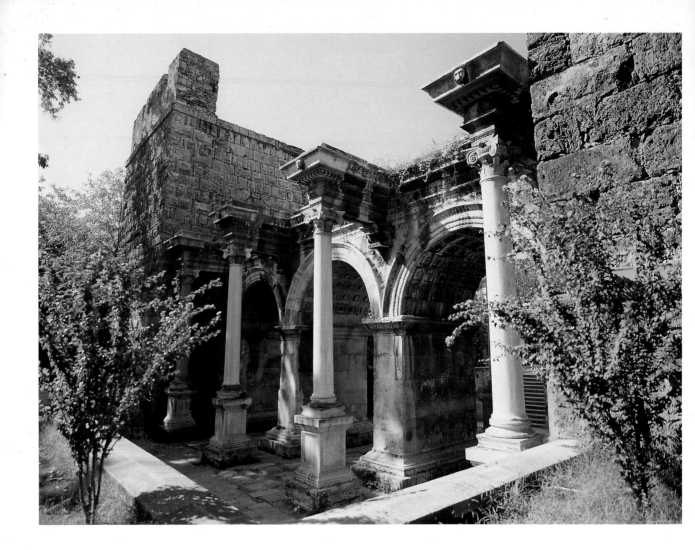

fish, cereals, cedar wood and saddle beasts, was incorporated under the Roman Empire in 133 B.C. in accordance with the bequest of the last Pergamene king. Famous personalities who visited the city in ancient times included St Paul and Barnabas in the 1st century A.D. and the Emperor Hadrian in the 2nd. Its fertile soil, its warm climate and its exceptional geographical situation exposed Pamphylia, which actually means "land of all tribes", to invasions by a number of very different civilisations throughout the course of its history.

In 1207 the region was captured by the Seljuks and in the 15th century by the Ottomans, after which it was populated mainly by Turks.

In 1918-1921, after the end of the First World War, the whole region was occupied by Italian forces.

Antalya is also one of the most important centres of art and culture in Turkey and is enlivened by various cultural activities such as the annual Art and Film Festival and Jewel Festival. Another of the specialities of the region is the preparation of jams made from all sorts of local fruit and vegetables.

The harbour area is undoubtedly the most interesting part of the city. Although construction was begun at the time of the foundation of the city the surviving remains generally date back to the 3rd century A.D. with traces of Roman and Ottoman restorations work in the upper parts of the walls.

The marina is surrounded by numerous bars, cafés, restaurants and tea-gardens, and from the tea-gardens, set on the top of the cliffs, high above the harbour, one can enjoy a marvellous

Antalya, Hadrian's Gate.

Düden Waterfalls.

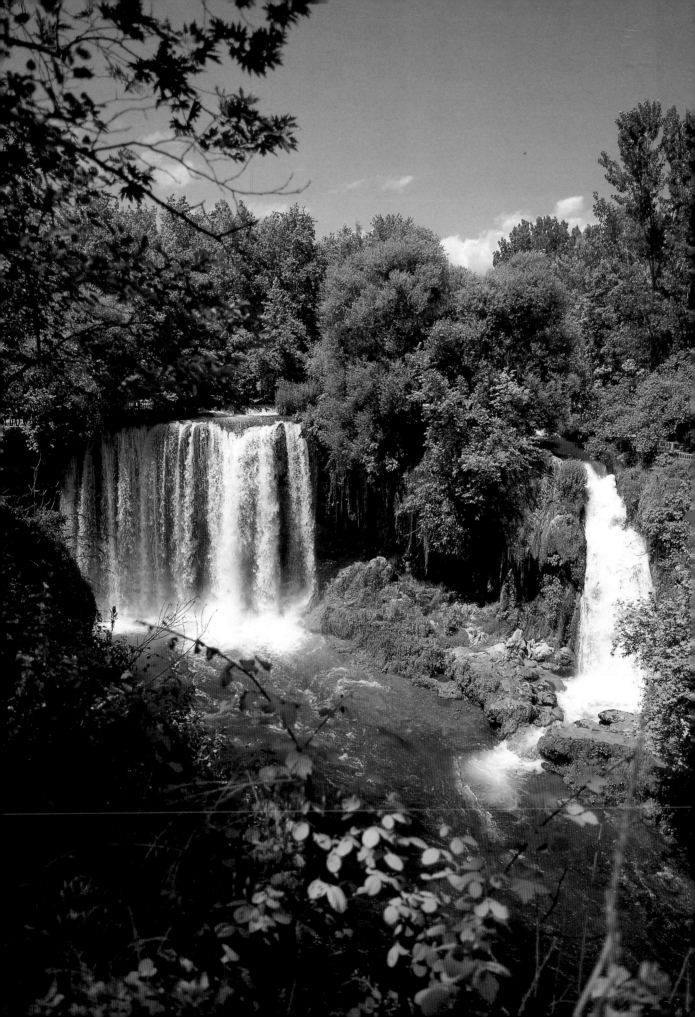

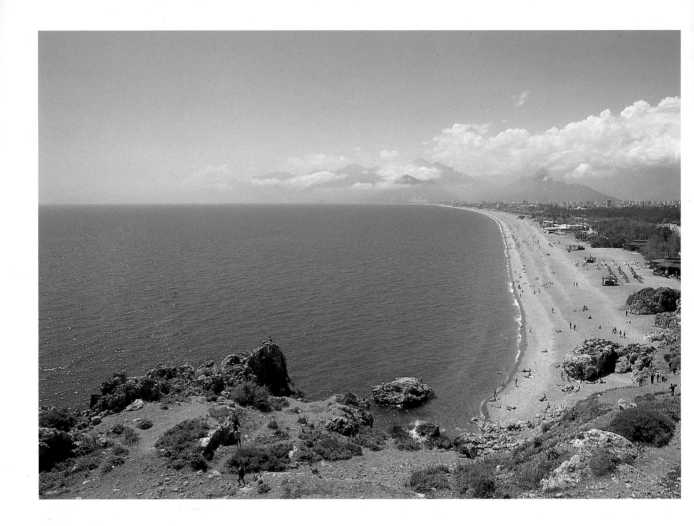

bird's eye view of the loveliest part of the old city. Since the 1970s, many of the old stone or wooden Ottoman houses that line the narrow streets contained within the old defence walls have been restored and converted into pensions, hotels and restaurants.

The Fluted Minaret in Republic Square, which has become the symbol of the city, belongs to the multi-domed mosque built by the Seljuk Sultan Alaaddin Keykubad at the beginning of the 13th century.

The minaret itself, which rises to a height of 38 m, rests on an octagonal base supported by a square stone plinth. Among the monuments located within the walls, the most interesting is the Truncated Minaret.

This minaret, which was partially destroyed by an earthquake, was added in the 14th century to a large edifice originally constructed as a temple in the 2nd century A.D. This was converted into a church during the Byzantine period and, finally, into a mosque by the Ottomans.

The Hıdırlık Tower, which rises to a height of 14 m on the cliffs to the south of the harbour entrance, was built as a lighthouse in the 2nd century A.D.

From the tower, a short walk takes one to the Karaali Park, whose tea-gardens, with their trees and pools, offer delightful coolness and shade on a hot summer afternoon together with a marvellous view over the city with the peaks of the Taurus Mts in the background.

The section of the city walls on the east towards the ancient city of Perge contains a very well-preserved triple-arched monumental gate in the form of a Roman triumphal arch. Built in 130 A.D.

Antalya Konyaaltı Beaches.

Different scenes from Antalya.

Kurşunlu Waterfalls.

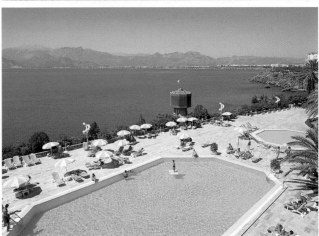
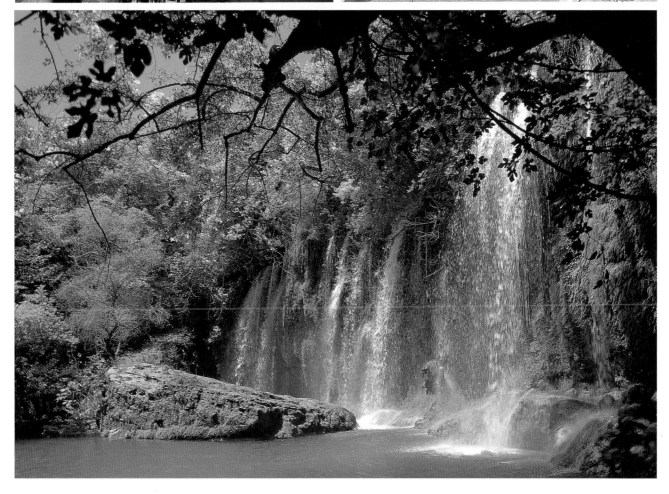

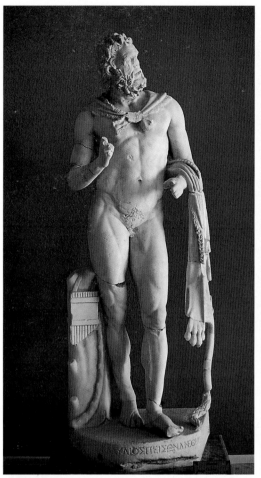

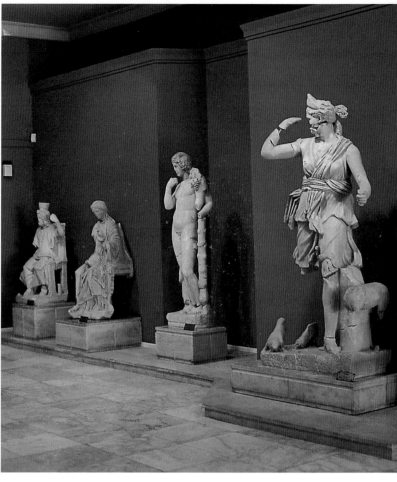

on the occasion of the Emperor Hadrian's visit to the city, it is known as Hadrian's Gate after the Emperor to whom it was dedicated. One of the places that must definitely be visited during a visit to Antalya is the modern Archaeological Museum in the western part of the city. In 1972 the Antalya Archaeological Museum was transferred to this new building situated by the side of several 5-star hotels at the top of the road leading down to Konyaaltı beach. The exhibits were re-arranged in 1985.

Here are preserved the most interesting of the findings discovered in the region, beautifully arranged in thirteen sections, with a large number of statues and excavations exhibited in the garden. All the well-preserved findings unearthed during the excavations carried out in the ancient cities around the region are

Exhibition Halls of Antalya Museum.

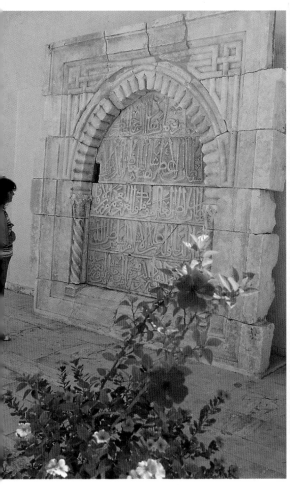

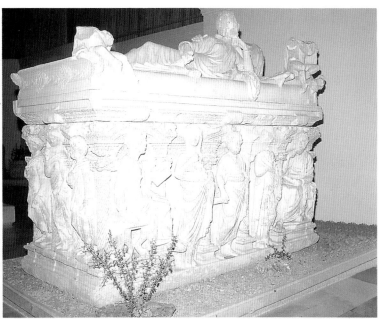

brought here for exhibition. The museum contains an extraordinarily rich collection of objects ranging from prehistoric stone implements to statues of the gods, from Roman imperial sculpture to Roman and Greek coins, and from ancient floor mosaics to ethnographic artifacts of the Ottoman period.

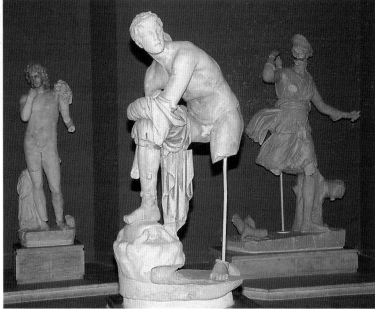

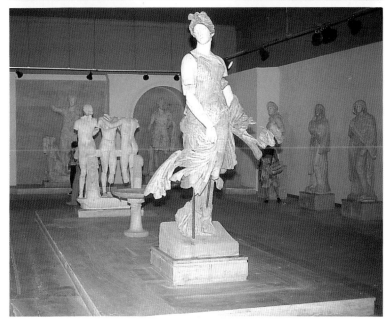

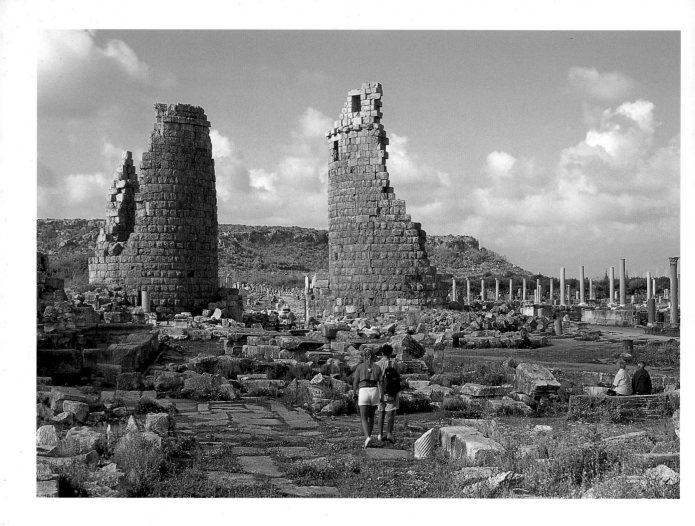

P E R G E

The visitor reaches the ruins of the ancient city of Perge by turning off the Antalya-Manavgat highway at a point 15 km from Antalya and proceeding 2 km east from the country town of Aksu. In ancient times Perge was a port city on the trade route between the ancient provinces of Ionia and Pamphylia. The city was joined to the Mediterranean 11 km away by the Cestros river, now known as the Aksu, which was then navigable right up as far as to the city. The river has now changed its channel and flows at a distance of about 5 km from Perge.

Like other Pamphylian cities such as Sillyon and Aspendos, which were founded around the same time, Perge was, for reasons of defence, situated at some distance from the sea on a flat-topped hill 60-70 m in height. The legendary founder of the city, which, judging from its ruins, reached a very high level of wealth and civilisation, was the hero Calchas, who is said to have come with his tribe to settle in the area after the Trojan War.

In Perge, the greatest reverence was shown to Artemis, known here as "Vanassa Preiie", or "Pergaean Queen" in order to distinguish the local goddess from the goddess of the same name worshipped in other cities. Indeed, the cult of the Pergaean Artemis, like that of the Ephesian Artemis, closely resembled the cult of the Anatolian Mother Goddess. Of the great temple of the goddess, which was of great importance for all the other cities of the region, not the slightest trace now remains, the building having been destroyed in the Christian

Perge,
Hellenistic Gate.

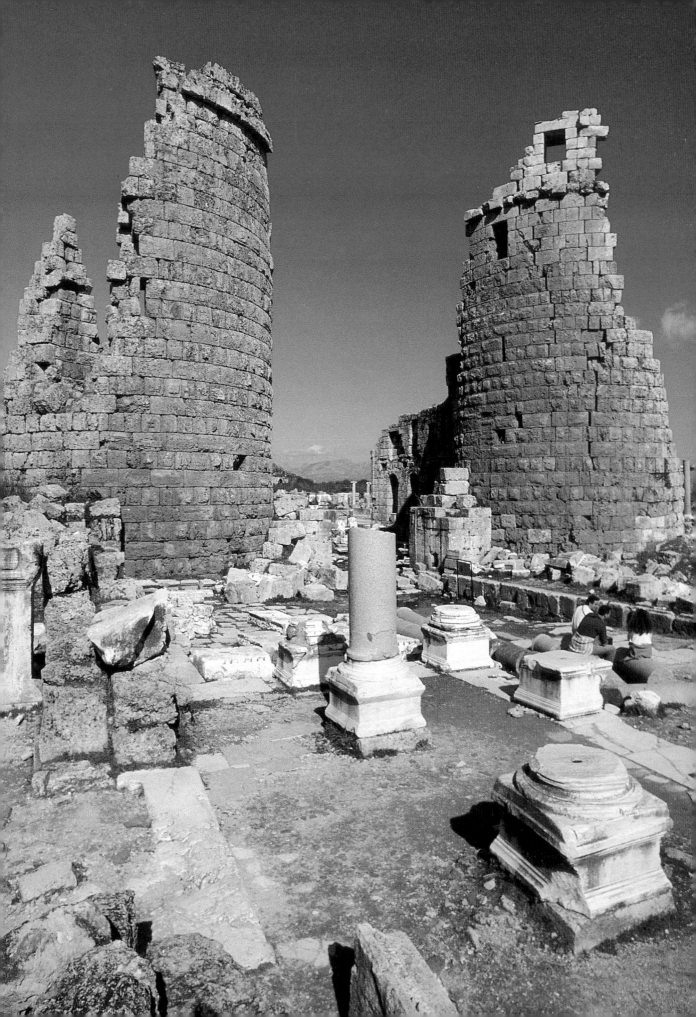

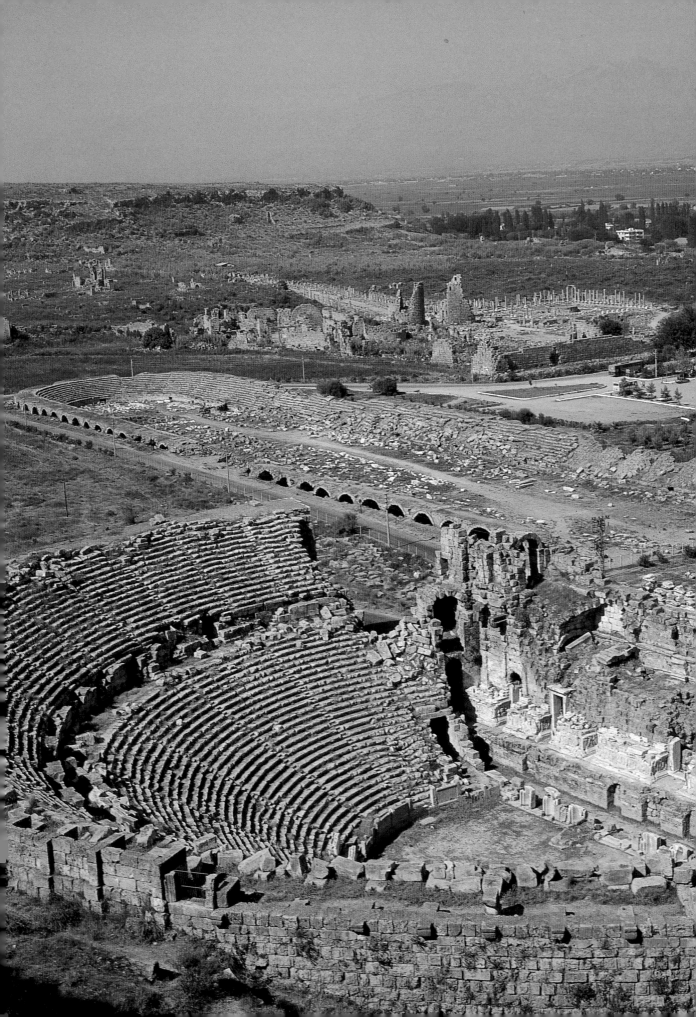

era, very probably during an attempt to remove all memory of the existence of the cult.

The city, which is thought to have been founded at the beginning of the 1st millennium B.C., came under Lydian hegemony at some date before the 7th century and under Persian hegemony some time later.

After it surrendered to Alexander the Great in 333 B.C., it was used for some time as a military garrison. Captured by the Romans in 188 B.C., it was visited in the 1st century A.D. by St Paul and Barnabas, who founded a Christian community in the city. In the 2nd century, Perge gained much in beauty from the benefactions of Plancia Magna, one of the wealthiest women in the city, and in the 3rd century it was accorded the status of "metropolis".

In later periods the river was gradually tranformed into a marsh, which led many of the citizens to abandon the city, many

more leaving it for the comparative safety of Antalya in the 7th century when the city became exposed to Arab raids. When the Seljuks arrived here they found only a small village amidst the ruins of the once wealthy city.

Among the most notable citizens of 3rd century Perge may be mentioned Apollonius, a follower of Euclid, who devoted his life to the study of conical cross-sections, and the philosopher Varus. At the same time, Perge contained the most important school of sculpture in the Mediterranean region, surpased in fame and importance only by the school of sculpture in Aphrodisias. A large number of the statues produced here are now exhibited in the Antalya Archaeological Museum.

The first building one encounters on approaching the city is the theatre in the Greco-Roman style built in the first half of the 2nd century against the eastern slope of Kocabelen Hill. The facade

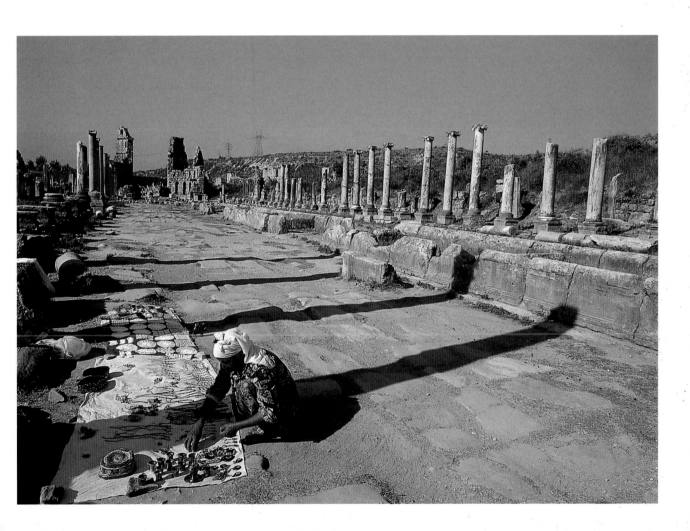

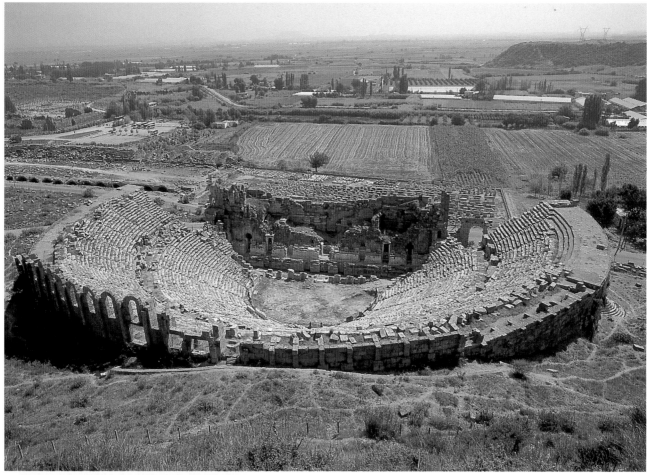

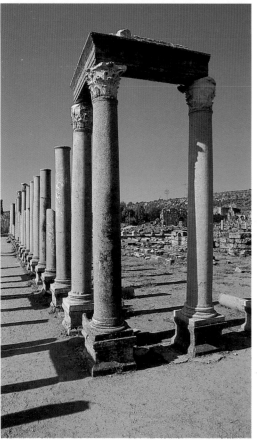

towards the road was converted at a later period into a Nymphaeum or monumental fountain. The cavea is divided by a broad diazoma with 19 tiers of seats below and 23 above, giving the theatre a total capacity of 12,000. The stage building, which collapsed as a result of earthquakes, is adorned with a frieze of Bacchus, god of wine and the theatre.

Directly opposite the theatre, on the right hand side of the road, lies the stadium, one of the best-preserved buildings of this type in Anatolia.

A U-shaped edifice 234 m long and 34 m wide, it had 12 rows of seats, with space for 12,000 spectators.

It was constructed on a series of arches, thirty on the long sides and nine on the short, containing shops and entrance doors, with one entrance door to every three arches.

Ancient city of Perge, Theatre.

A view from Perge ancient city.

Stadium of Perge.

Perge, Monumental Fountain (Nymphaeum).

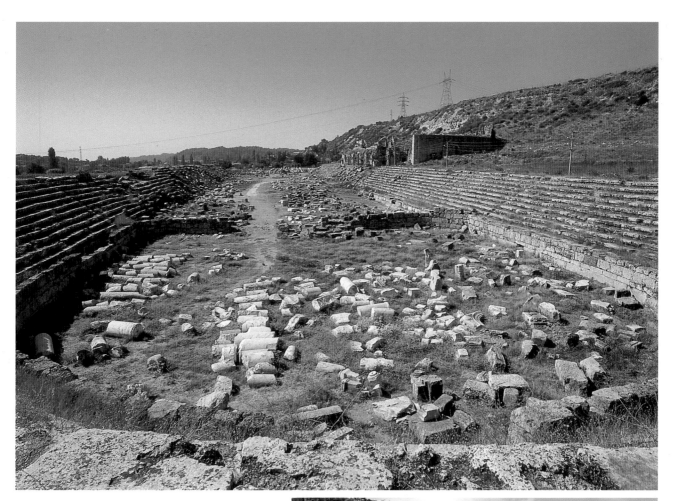

Originally used for athletic contests and gladiatorial combats, it was later adapted for wild beast shows.

The first gate encountered at the entrance to the city is the relatively new south gate erected in the 4th century A.D. The Hellenistic gate 90 m behind this, strengthened with cylindrical towers 13 m in diameter, dates, like the city defence walls, from the 3rd century B.C. Gates are also to be seen on the easter and western sides of the city.

The horse-shoe shaped courtyard behind the towers, designed for ceremonial use, was surrounded by walls revetted with marble and with niches containing statues of the gods and distinguished citizens.

Between the Roman and Hellenistic gates stands the largest Roman bath in the province of Pamphylia, with a palaestra, used for physical exercises, in

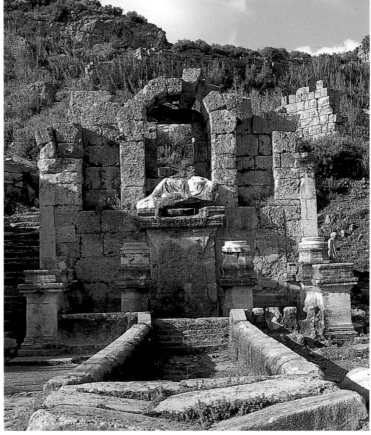

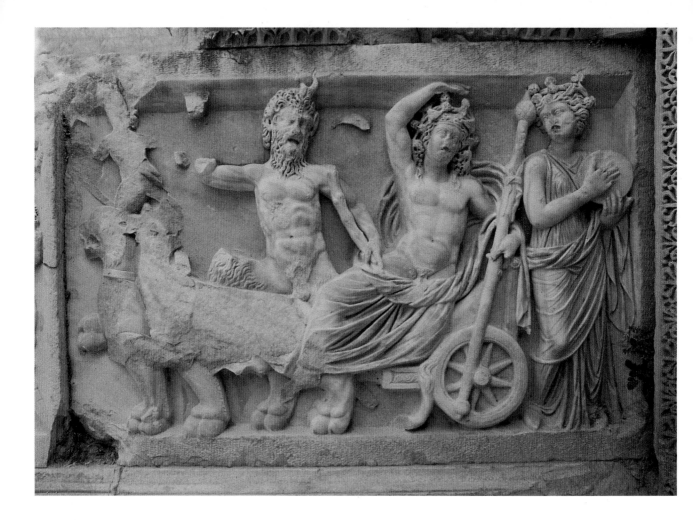

A beautiful relief, Perge Theatre.

front. This is followed by the apodyterium (dressing-room), frigidarium (cold room), tepidarium (warm room), caldarium (hot room) and sudatorium (the part of the bath in which the water was heated), all arranged in parallel. The building originally had a wooden roof covered with tiles.

The black and white geometrical decoration on the floor and the heating tunnels and arches of the hypocaust system have survived in a good state of preservation. In front of the bath stood a monumental fountain.

To the right of the gates lies an agora, or market place, measuring 75 x 75 m and dated to the 4th century B.C. Surrounded by a colonnade with Corinthian capitals, it originally had a temple in the centre but this was later replaced by a round building used as a fountain.

In order to make shopping easier and more pleasant for the citizens of the town the pavements were adorned with mosaics and awnings were hung between the columns and the shops. These shops were all identical in size, with signs carved in stone indicating the type of goods sold. For example, a butcher's shop was indicated by a knife and a hook. The Roman gate at the entrance to the city is connected to the acropolis 300 m away by a street 20 m wide flanked by a portico with columns, mosaic pavements and shops.

There was a water channel down the centre and the ruts made by the wheels of the carts or carriages are still clearly visible. The surplus water from the fountain at the end of the street flowed over stones placed every 8 m perpendicular to the flow of the water, giving the shoppers a certain feeling of

A general view
of Sillyon
Ancient town.

refreshing coolness. Four columns about half-way up the street display reliefs depicting the goddess Tyche, Calchas, the founder of the city, the supreme goddess, Artemis Pergaia, and Apollo in a chariot drawn by four horses. The city also contains a number of dwellings not open to visitors as well as the remains of public buildings dating from the Hellenistic and Roman periods. The canalisation sytem constructed thousands of years ago is still in an excellent state of preservation.

SILLYON

Sillyon remained an important centre of habitation from Hellenistic to Seljuk times. Situated near the little village of Yarıköy to the north of the Antalya-Manavgat highway, the city was founded, for reasons of defence, on a high flat-topped hill. Like Perge and Aspendos, Sillyon is said to have been founded by tribes arriving in the region after the Trojan War. An important centre of habitation in the Hellenistic and Roman periods, Sillyon survived into the Byzantine era as an important religious centre. The absence of archaeological excavations, its distance from the main road and its comparatively small dimensions account for its failure to attract more than a very few visitors. Visible remains include terrace houses, a temple and city defence walls dating from the Hellenistic period, together with a few temples, a stadium, a theatre, a palaestra, an odeon and a number of cisterns and towers from Roman times.

The Seljuks, who captured the city in the 13th century, built a small mosque and a small keep surrounded by the city walls.

ASPENDOS

At the end of a road branching off left just before the Köprüpazarıçayı Bridge about 35 km along the Antalya-Manavgat highway there is a yellow sign pointing to the ancient city of Aspendos. In Ancient times, this city, which possesses the best preserved Roman theatre in Anatolia, was a port connected to the sea by the river Eurymedon, now known as the Köprüpazarıçayı.

Like the other cities of Pamphylia, Aspendos was said to have been founded after the Trojan War by the legendary Mopsus. Very little excavation has been conducted in the city so far, with the result that there are very few remains of the Hellenistic period. In the 5th century the city had symbolised its independence by minting a silver coinage but until its liberation by Alexander the Great in 133 B.C. it remained under Persian rule. By the 1st century A.D. it had become one of the three most important cities in Pamphylia. In the 13th century it came under Seljuk hegemony, and it was during this period that a bridge was erected over the river and a caravanserai built inside the theatre.

In the 2nd and 3rd centuries the main source of livelihood of the population was trade in olive oil and the salt obtained from the nearby Lake Capria. The wine made from the grapes produced in the local vineyards were exported to all parts of the Mediterranean basin. Of the ruins to be found on the hill nearly 60 m in height on the western bank of the Eurymedon river the most important and best preserved are the Roman theatre and the aqueduct.

The first object of interest one encounters after leaving the Antalya-

Aspendos, Theatre.

Three different views of Aspendos Theatre.

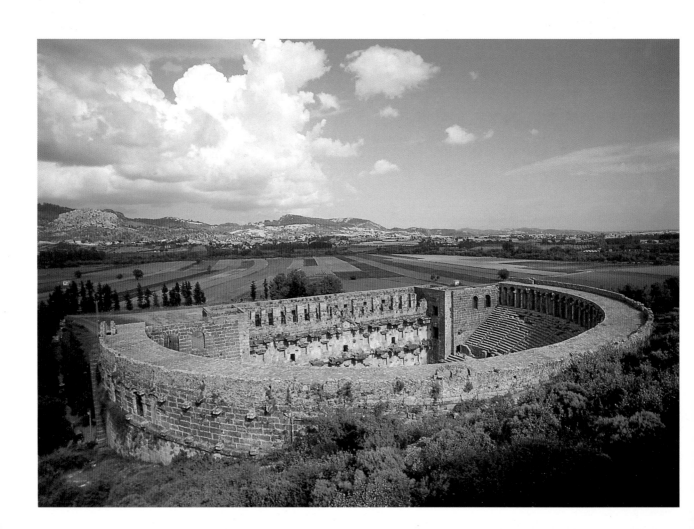

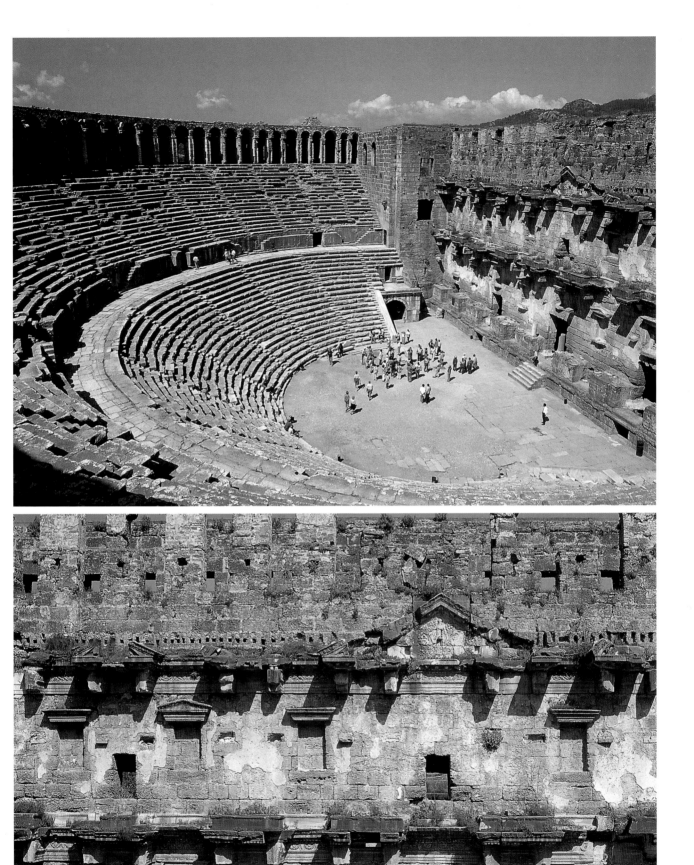

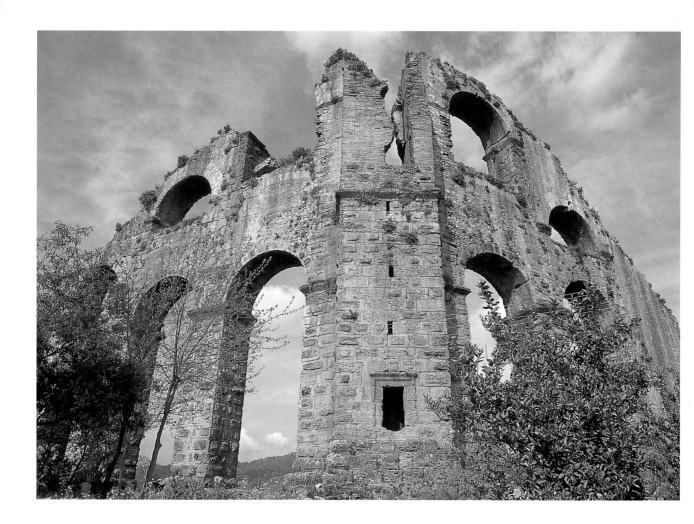

Manavgat highway is the stone bridge built by the Seljuks in the 13th century. In order to save time and money, the bridge was constructed on the foundations of an older bridge dating from the Roman period. From here the road continues towards the north, winding its way between small restaurants and some ruins of little general interest, to arrive at the 2nd century Roman theatre. This was built during the reign of the Emperor Marcus Aurelius by two wealthy citizens, the brothers Curtius, and designed by Xenon, one of the most famous architects of the time. It is constructed in the typically Roman style with the seats built against the slope of the hill. The two-storey stage building has survived in all its magnificence.

Built of sandstone, limestone and marble the theatre possesses marvellous acoustics. In the 3rd century, the semi-circular orchestra, which is 24 m in diameter, was surrounded by high walls, making it suitable for wild beast shows.

The cavea, or auditorium, is divided into two by a central passage known as the diazoma. With 20 tiers of seats above the diazoma and 21 below, the theatre can seat a total of 20,000 spectators. Several of the seats are marked by Greek letters or symbols, showing that they were reserved for certain people. On the side walls can be seen sockets into which posts were inserted to hold an awning stretched over the cavea in the summer months to protect the spectators from the sun. Boxes of honour reserved for local notables and administrators were placed over the spectators entrances on each side. The front rows of seats were reserved for priests, high-ranking soldiers, leading bureaucrats and wealthy citizens of the town. The colonnade of 59 arches

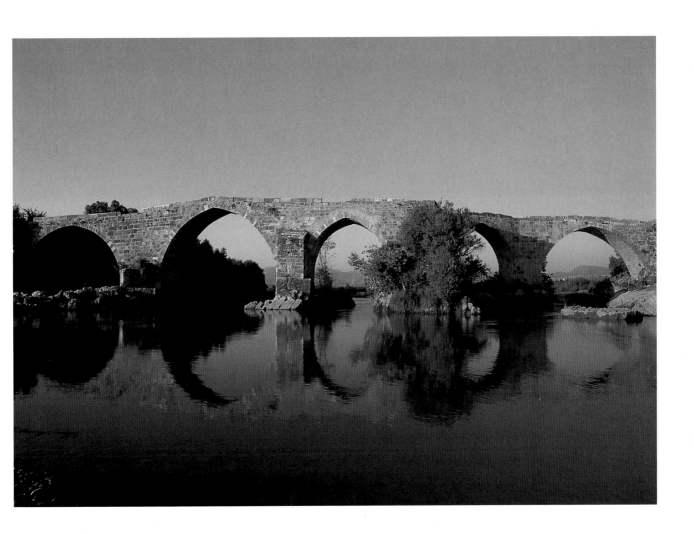

Aspendos,
Ancient Bridge.

surrounding the upper part of the theatre was added at a later date in order to improve the acoustics. These have recently been very carefully restored.

The stage building is 10 m high and 62.5 m wide with two storeys each containing eighteen niches in which statues were placed. Each storey also had a row of twenty columns, with Ionic orders in the lower storey and Corinthian orders in the upper.

The young male figure in the pediment above the centre of the stage building represents Bacchus, the god of wine and the theatre. The intermediate floors of the stage building were destroyed by earthquakes. There are five entrances in the outer façade with four rows of windows above this.

Small objects, such as theatrical masks, are displayed in the small exhibition hall in the lower storey of the stage building on the left hand side of the theatre entrance. The red-painted zigzag designs clearly visible on the walls on the right hand side of the stage buildings are survivals of the time when the building was used by the Seljuks as a caravanserai. Used in Roman times for large public gatherings and in Ottoman times for sporting activities such as camel wrestling, the Aspendos theatre was restored in 1930 on the orders of Mustafa Kemal Atatürk, the founder of the Turkish Republic, and given classified status. The theatre continues at the present day in its service to culture as a venue for festivals of music and the arts.

The most interesting building in Aspendos after the theatre itself is the aqueduct dating from the 2nd century A.D. presented to the city by a wealthy citizen, named Tiberius Claudius.

The aqueduct is 15 km long, with a

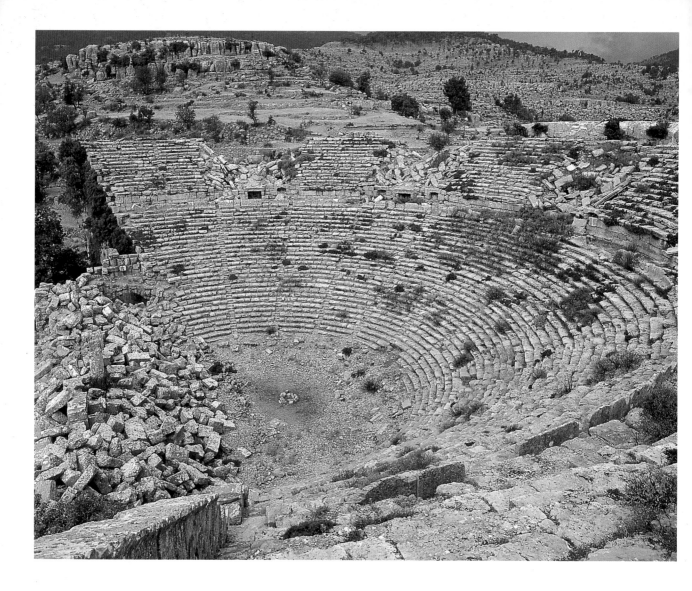

central section 925 m in length rising in places to a height of 15 m. Before the construction of the aqueduct the city was supplied with water from wells and the Eurymedon. At the north and south ends of the aqueduct there are water pressure towers 30 m in height.

Apart from the well-preserved theatre and aqueduct there is also a stadium 215 m in length, a basilica 105 m in length, a two-storey nymphaeum (monumental fountain), three necropolises, two domed bath buildings and an agora in the upper city. No scientific excavation has so far been carried out on the site.

The modern jewellery workshops and sales outlets on the road leading from the main highway to the theatre are well worth a visit.

THE BEŞKONAKLAR VALLEY NATIONAL PARK AND SELGE

One of the three National Parks in the province of Antalya, the Beşkonaklar Valley Park is of quite exceptional beauty and should definitely be seen by all visitors with the time to spare. The Köprüpazarıçayı winds through the valley, forming the finest rafting site in the whole Mediterranean region. At the same time, all those interested in nature, trekking and line fishing will find much to interest them here.

The valley is reached by an imposing Roman bridge that spans the river like a necklace. Now known as the Olukköprü

Ancient city of Selge, Theatre.

Ancient bridge on Köprüçay River, Selge.

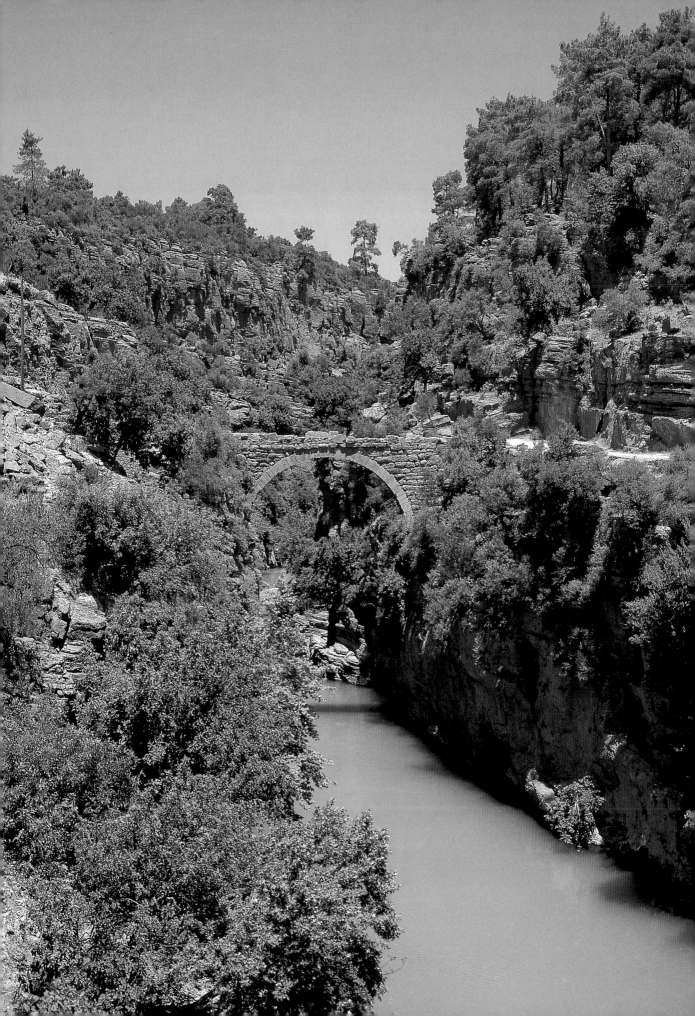

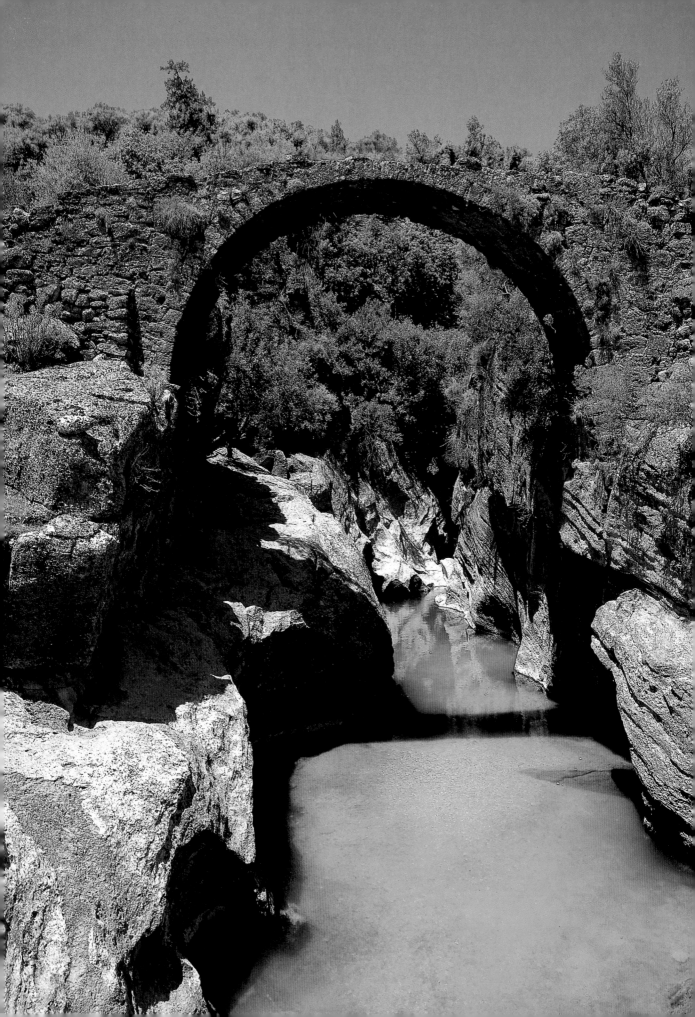

Bridge, it is open only to light vehicles. After the bridge begins the climb towards the mountains, where at about 1,700 m you will notice a change in the colour and form of the flora.

The cedar forest, ruthlessly exploited by practically all the various civilisations right up to the present day, has now been placed under conservation. At the end of a climb through an atmosphere rich in oxygen and the fresh smell of vegetation you will find yourself in Selge.

Selge, now known as Zerk, is situated on a small piece of level ground high up in the mountains, with simple village houses right next to or even on top of the ancient ruins.

On seeing the fair-haired village children that come out to greet you and the wild goats scurrying hither and thither on its ancient roads you will feel yourself transported to quite another time and place.

Selge, a city which minted its first coins in the 5th century B.C., was an important Pisidian centre for the trade in olives, olive oil, forest products, fruit and medicinal herbs.

The best preserved of the ruins is the Greco-Roman theatre with a seating capacity of 10,000. The ancient stadium, with village houses scattered among its ruins, offers a fascinating subject for the photographer.

The remains of a temple dedicated to Zeus, the tutelary deity of Selge, lies on a hill above the village. Considering Selge's location, surrounded by snow-covered peaks and exposed to violent rain-storms and frequent thunder and lightning in spring, the Selgeians' choice of Zeus as their protector is very understandable. After all, wasn't thunder and lightning the symbol of Zeus, Father of the Gods?

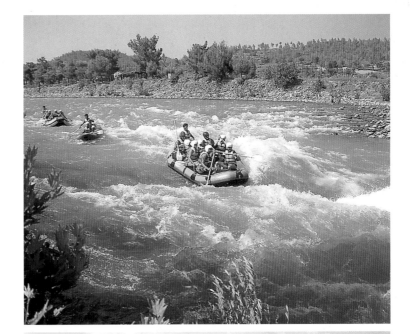

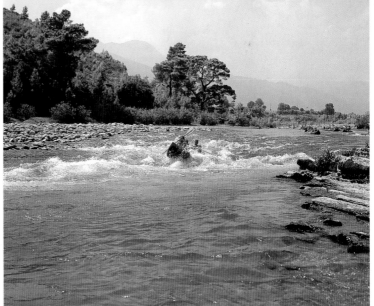

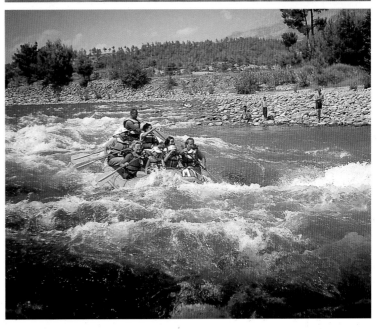

Another ancient bridge on Köprüçay River.

Rafting activities, Köprüçay River.

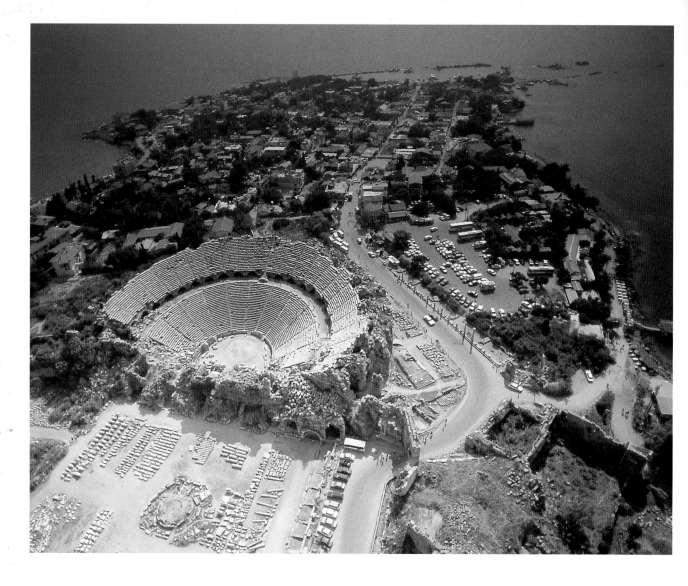

S I D E

The ancient city of Side, a word meaning "pomegranate" in the language peculiar to the region, is reached by a road branching off to the right shortly before Manavgat. Although the modern holiday resort has swallowed up almost the whole of the archaeogical site, the ruins nevertheless remain the most important in Pamphylia.

The first settlement has been dated to the 1st millennium B.C. According to Strabo, it was colonised by emigrants from Cyme in the Aegean province. Persian hegemony was ended by the arrival of Alexander the Great, and the warm hospitality the city offered the Macedonian conqueror was rewarded by generous benefactions.

Although the city began to develop very rapidly after this date, it underwent a number of calamities in the two centuries prior to the Roman period, including its destruction by the Rhodian fleet and its use as a base by the Cilician pirates, who converted Side into the largest slave market in the whole region. In the 1st century B.C., however, Pompey was sent here by the Roman Senate and succeeded in clearing the pirates from the sea, burning hundreds of their vessels in the process.

Now began the golden age of the city, with the construction of new defence walls to provide for the protection of a population which had now spread out

Side, general view.

Side, Apollon Temple.

40

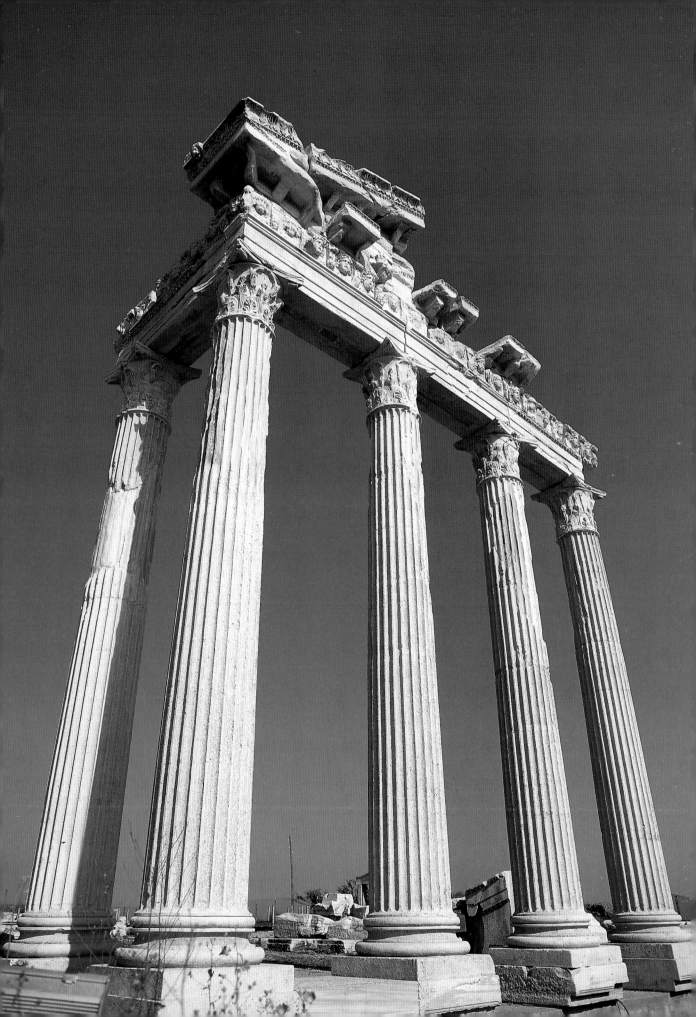

beyond the old walls of the Hellenistic period. Both lines of walls are clearly visible at the present day.

In the 2nd century A.D. the city was practically rebuilt, with new constructions including the largest theatre in the region, with a capacity of 18,000, five temples, three baths, two agoras, colonnaded streets, aqueducts and monumental fountains.

The defence walls were strengthened by conglomera material quarried from the sea or found on the beaches. The city retained its former importance during the early Christian period. but decline set in with the advent of Arab raids, the disintegration of the socio-economic system and the results of steadily intensifying pirate activity. By the 8th century, Side was no longer a city of any importance.

By the side of the road leading to Side lie the ruins of the aqueduct which was used to bring water to the great monumental fountain in the city from a distance of 35 km.

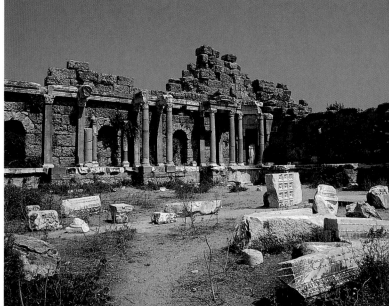

The present-day road follows the course of the ancient street and the entrances to the shops are clearly visible on the eastern side. The building now used as a museum situated on the left of the road leading to the theatre and the monumental fountain was the agora bath. The excavations begun immediately opposite this complex are now practically complete and the agora has emerged with all its columns and column capitals. This great agora, which consists of a square courtyard 75 x 75 m surrounded by porticos, was one of the most important commercial centres in the region. The round building in the centre of the agora was an altar dedicated to the Goddess Tyche-Fortuna. On the eastern side of the agora lie the remains of a very interesting two-storeyed building with very elegant stone carving.

This building was very probably used in the Roman period as a government

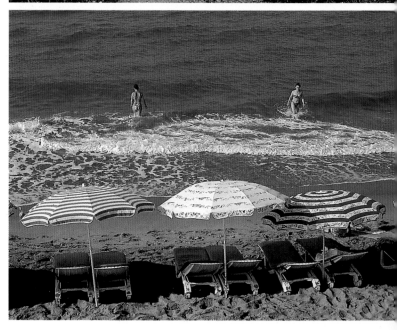

Different views from Side, Ancient Library.

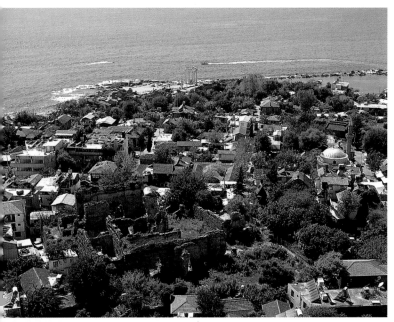

house, although some believe it to have been a library. The shell reliefs over the niches in this building testify to the great influence exerted by the sea in Sidetan culture. The statue in the niche on the south side is that of the goddess Nemesis.

A small gate on the road leading from the government house to the theatre gives access to the village by the eastern road, and a short walk along this road will very clearly reveal the extent to which the touristic village has encroached on the ancient site.

As you make your way past rows of touristic hotels, restaurants and bars, you will arrive, just before the sanctuary at the southern end of the peninsula, at the ruins of the Temple of Men raised on a semi-circular base.

Immediately after this, you will come to the Side sanctuary area containing temples of Athena and Apollo dating from the 2nd century A.D. These form a striking contrast to the inferior quality material and coarse workmanship displayed in the Byzantine basilica immediately behind them.

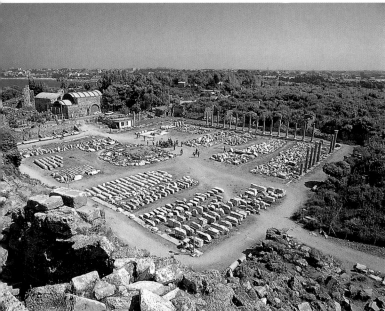

The twin temples are on a peripteral plan with 6 x 11 Corinthian columns. These temples also served as lighthouses with fire burning on their walls. Several of the columns and capitals of the temple of Apollo have been unearthed in recent excavations and re-erected. The Corinthian capitals on fluted columns and the reliefs with Medusa heads give some idea of the original magnificence of the temple. Passing the temple and continuing on our way along the shore of the peninsula, we take a look at the harbour, where the ancient breakwaters surrounding it are still clearly visible, and then turn again to the north to enter the ancient colonnaded street.

Here, concealed behind the various touristic establishments, stand the harbour baths, which played such a very important rôle in the life of the ancient Sidetans and where, according to the city

Different views from Side, Agora and Roman Baths (Side Museum).

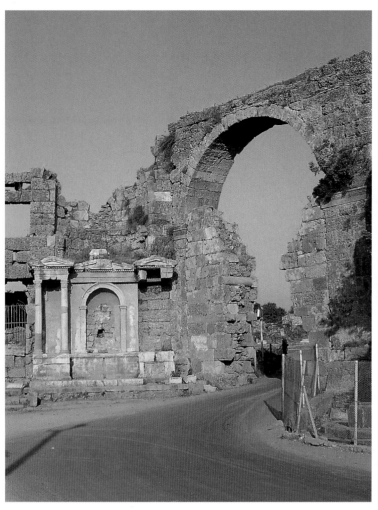

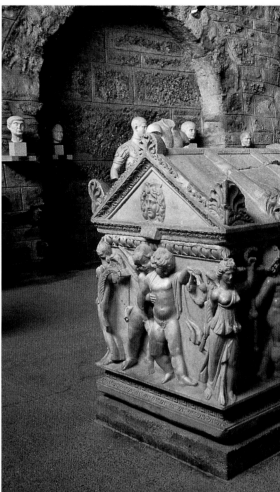

bylaws, seamen arriving in the city were obliged to wash before being permitted to enter the city or the agora. Continuing along the same road, we go through the gate in the Byzantine defence wall and arrive once again at the bath complex and the agora.

But now, immediately beside us, we find the theatre, the most imposing of all the monuments in Side.

A latrine is to be seen immediately under the stage building on the side towards the monumental fountain. The theatre itself is entered through a gate dating from the Byzantine period.

In order to defend the city, now much reduced in size as a result of the Arab raids and pirate attacks, the Byzantines constructed a defence wall immediately adjoining the stage building.

Unfortunately, an examination of the

Side Ancient City Gate.

The Eros Sarcophagus.

The statue of Hercules.

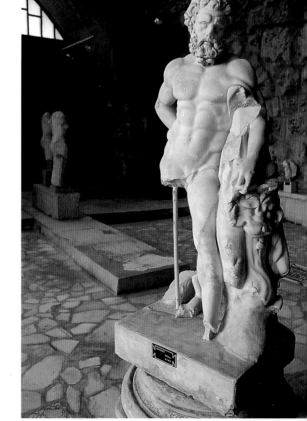

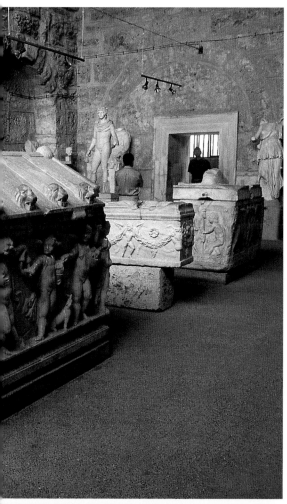

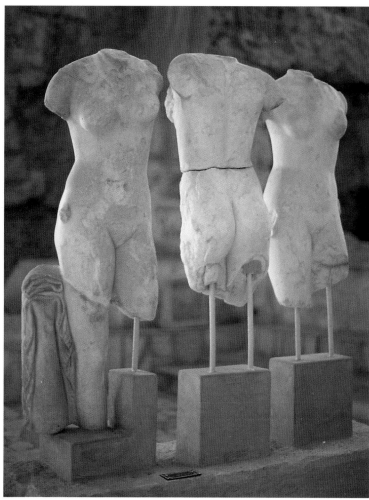

The Three Beauties.

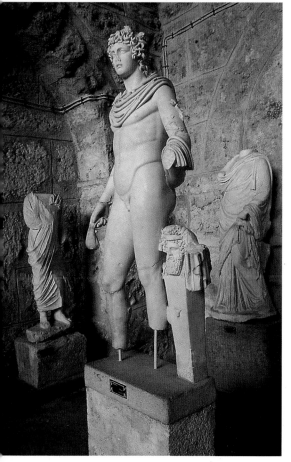

The marble statue of Hermes.

materials used in the construction, which included meticulously carved Roman columns, column capitals and other architectural elements, provides sad evidence of how Christian belief led to the destruction of a number of very fine pagan temples and other monuments.

The Side theatre was built over a small theatre of the Hellenistic period. As the city of Side is situated on a level plain with no hills against which the cavea could be built the necessary height for this enormous theatre was obtained by the construction of the great arches typical of Roman architecture.

This colossal theatre, displaying amazing skill in statics and a most impressive architectural technique, is one of the finest and most successful of all the edifices in the ancient world. Although several cracks and flaws caused

by earthquakes can be seen in the upper tiers, the building still preserves much of its original beauty and integrity.

No visit to Side is complete without seeing the collections in the small, but very rich museum in the bath complex. Exhibits include sarcophagi, temple friezes, burial finds and other small artifacts of very great interest.

MANAVGAT

Manavgat, an agricultural and agro-industrial centre 60 km from Antalya, is celebrated for its beautiful waterfalls.

Of the several waterfalls in the Antalya region two are particularly famous: Manavgat and Düden. These waterfalls are produced by sudden sharp drops in level in the course of rivers fed by the snows on the Taurus Mts.

The waterfalls lie 2 km along a road that branches off just before Manavgat 7 km from the ancient city of Side. Besides being used as a pleasure resort and picnic place by the inhabitants of Manavgat, the waterfalls form an essential item on the itinerary of every visitor to the area.

The Manavgat waterfalls, and the restaurants, cafés and stalls selling all sorts of gifts and souvenirs, are thronged, particularly at weekends, by crowds of visitors from Antalya and the neighbouring towns and villages joined by thousands of tourists from all four corners of the world who come here to stroll around or find rest and recreation.

Considering that in this part of Turkey it is quite warm for nine months of the year you are advised, after a rather tiring visit to the ruins of Side, to cool off in this very interesting corner of the southern shore.

Two breathtaking views of Manavgat Waterfalls.

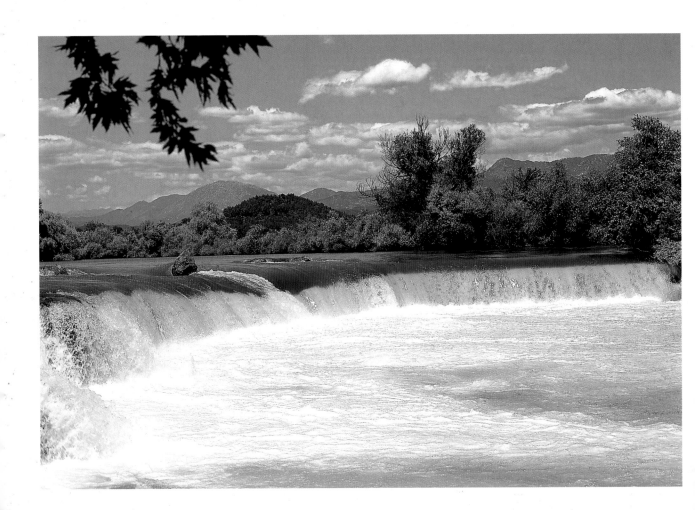

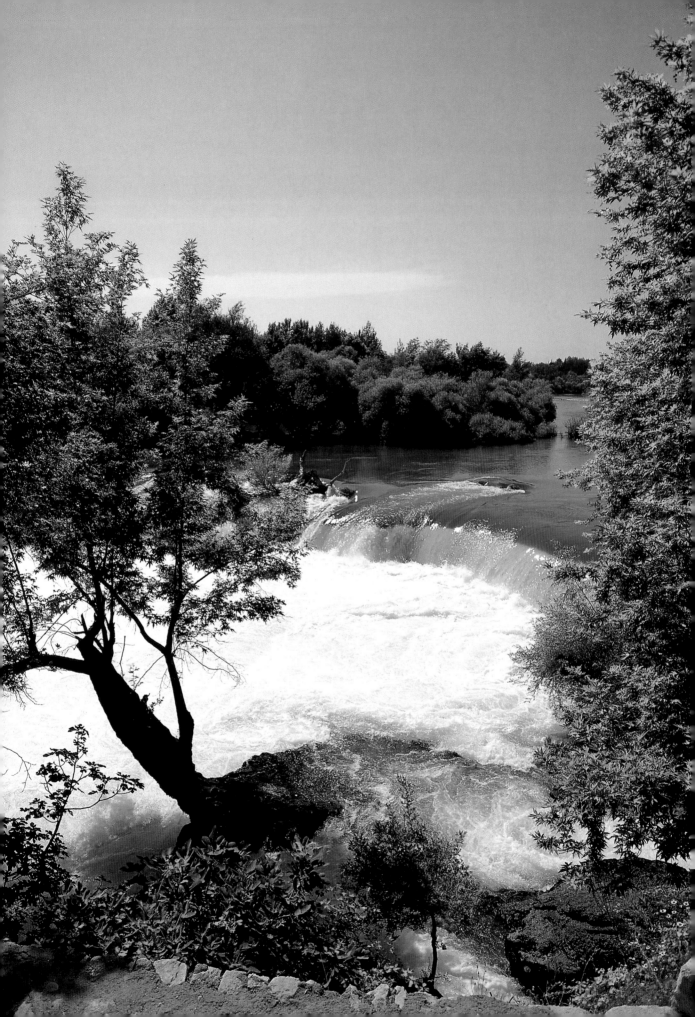

ALANYA

Crossing the Manavgat river we enter the ancient province of Cilicia. In ancient times, the most important town of the region was Coracesium, now known as Alanya. Although the date of the first settlement here is uncertain, the city is known to have been founded in the 2nd century B.C. by the sailors of Tryphon, a famous pirate who held the whole trade of the Eastern Mediterranean in his power. Located at a distance of 135 km from Antalya, Alanya is one of the most beautiful tourist centres on the south coast of Turkey and a district containing a number of sites of quite exceptional historical significance. The plain created by the alluvium brought down by the Dim and Ova streams from the Geyik Mts that form part of the Taurus range, is the most important banana growing area in Turkey. The historical peninsula is lined with beaches, each lovelier than the other, the most famous being the Beach of Cleopatra, at which Cleopatra, who married Antony in 40 B.C., is said to have stopped for a time during a sail along the southern shores.

The real development of the city began after Pompey's successul campaign against the pirates in 65 B.C. During the Christian epoch it became the seat of a bishopric and the name was changed to "Kalonoros", meaning "Fine Mountain". However, as in several other important cities on the shores of the Mediterranean, decline set in as the result of the Arab raids that began in the 7th century A.D. The capture of the city by the Seljuk Sultan Alaeddin Keykubad in 1221 was followed by extensive building operations, including the construction of the castle, which has survived in an excellent state of preservation. Alanya Castle, with its over 7 kilometres of walls

View of Alanya from the Castle.

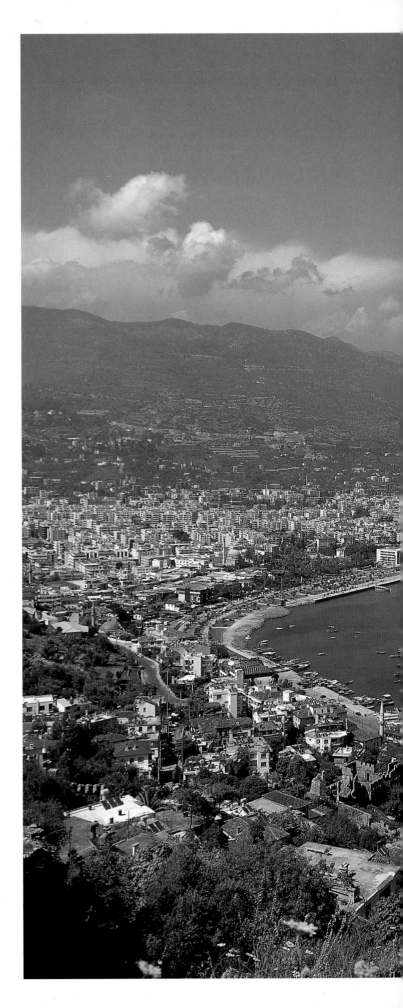

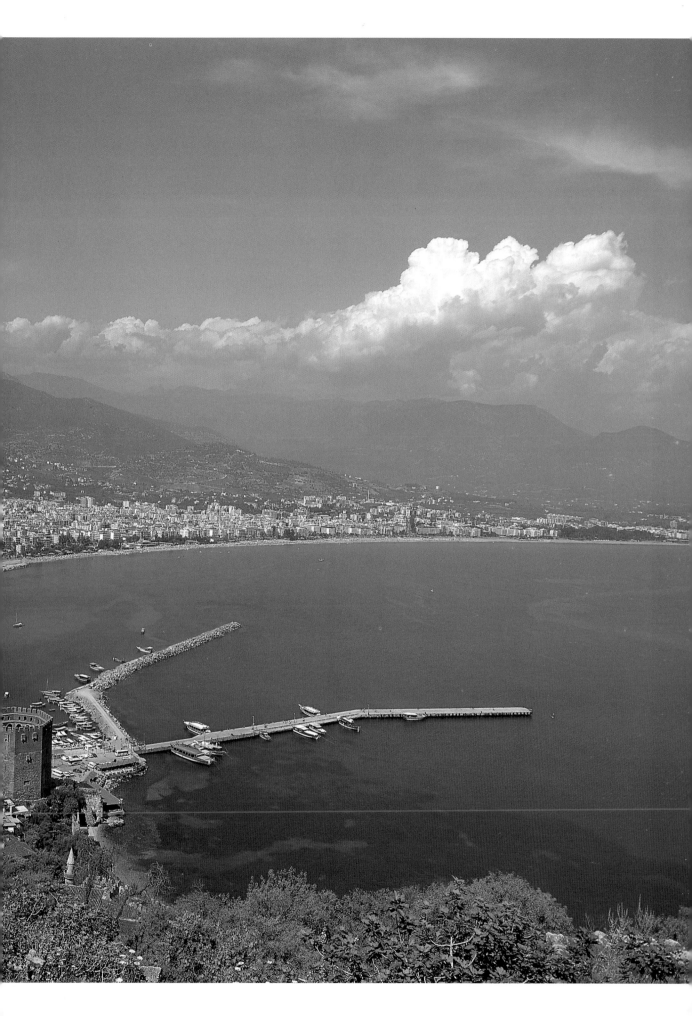

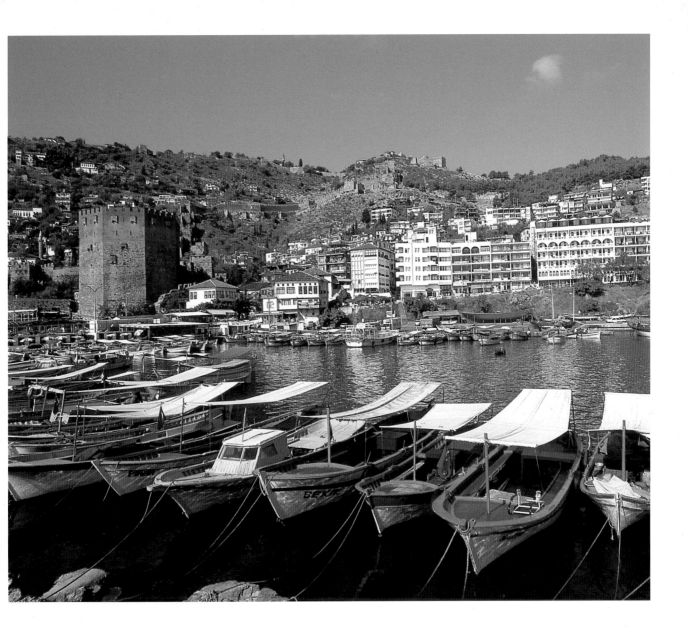

Alanya, view Kızılkule (Red Tower) from the harbour.

Alara River and Alara Castle (Seldjuk Period).

and over one hundred towers, is the most famous castle on Turkey's Mediterranean coastline. The most important of the old monuments to be seen as one enters the gate through the outer defence walls are the Süleymaniye Mosque, a very fine specimen of Ottoman architecture, and the caravanserai.

The "Akçebe Sultan Tekkesi (Dervish Lodge) and Tomb" in the central keep are also well worth a visit.

While entering the inner keep you will see the summer palaces of the Seljuk Sultans, who spent the summer months in Konya and Beyşehir but, as the winters there were very severe, preferred to spend the cold months in Alanya.

The Sultans therefore took steps to make travel between Konya and Alanya easier by constructing a good road and a number of caravanserais, the most famous of these being the Alara Han built by the Seljuk Sultan Alaeddin Keykubad in the first half of the 13th century, a building of particular importance on account of its very interesting architecture and the quite extraordinary beauty of its monumental entrance door.

Immediately beside the Seljuk Palace stands the famous 11th century church of St George. Its careful preservation and its survival in such excellent condition immediately adjacent to a Sultan's palace

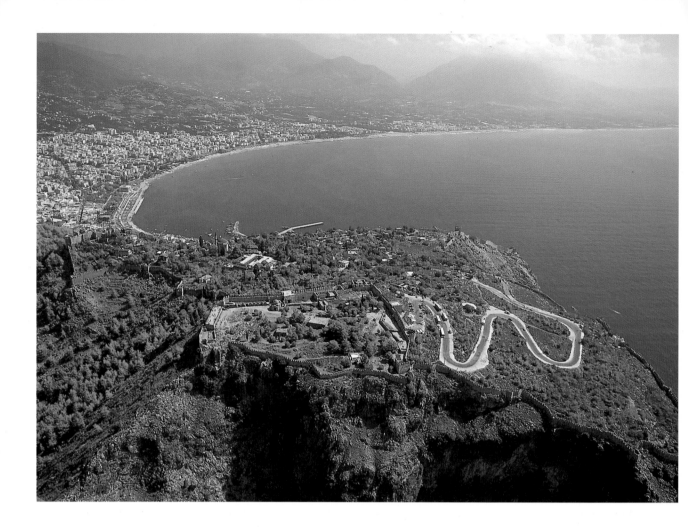

constitutes a remarkable testimonial to the religious tolerance displayed by the Anatolian Turks.

The five wells to be seen by the side of the church were constructed to ensure an adequate supply of water to the palace. The arched building you see on the right as you make your way towards the terrace on the north was the barracks of the palace guards.

The roof of the store-rooms of the inner keep offer a magnificent panoramic view over the whole of Alanya, the historical peninsula and the Alanya and Cleopatra beaches.

The most interesting monument in the harbour and landing-stage area is the old "Red Tower", so called because of the colour of the bricks of which it is constructed.

This tower, 33 m high and built as a defence for the harbour and dockyard, which you can see on the eastern side of the peninsula as you climb up towards the castle, is particularly remarkable for its very interesting architecture.

A walk or boat trip along the shore, an indispensable feature of any visit to Alanya, will allow you to see the old dockyard at closer quarters.

Over the entrance can be seen a five-line inscription with the date 1227.

This dockyard is of great historical importance insofar as it lay at the origin of the Turkish fleet which later ventured out into the Mediterranean.

Visitors with a little time to spare are strongly advised to visit the small but very interesting museum.

Alanya Castle.

Alanya, the old Dockyard.

Alanya, Red Tower (Kızılkule).

Antalya Castle.

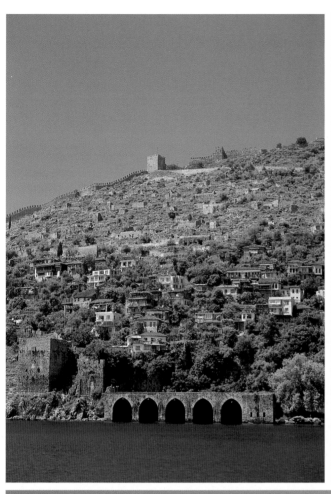

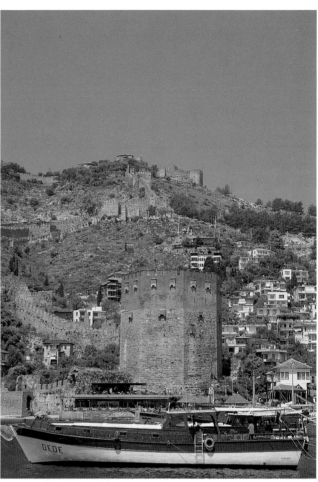

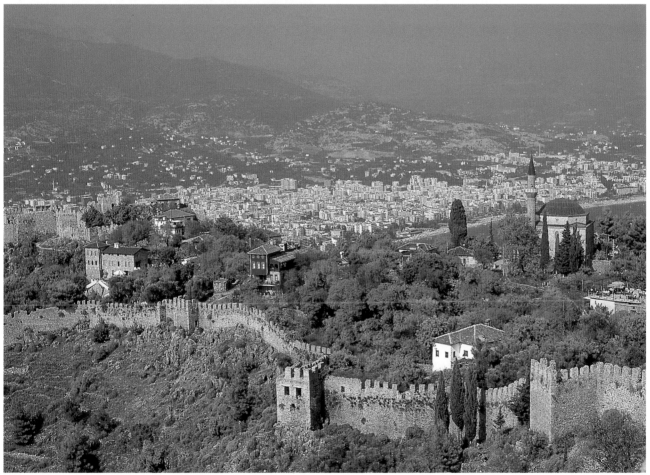

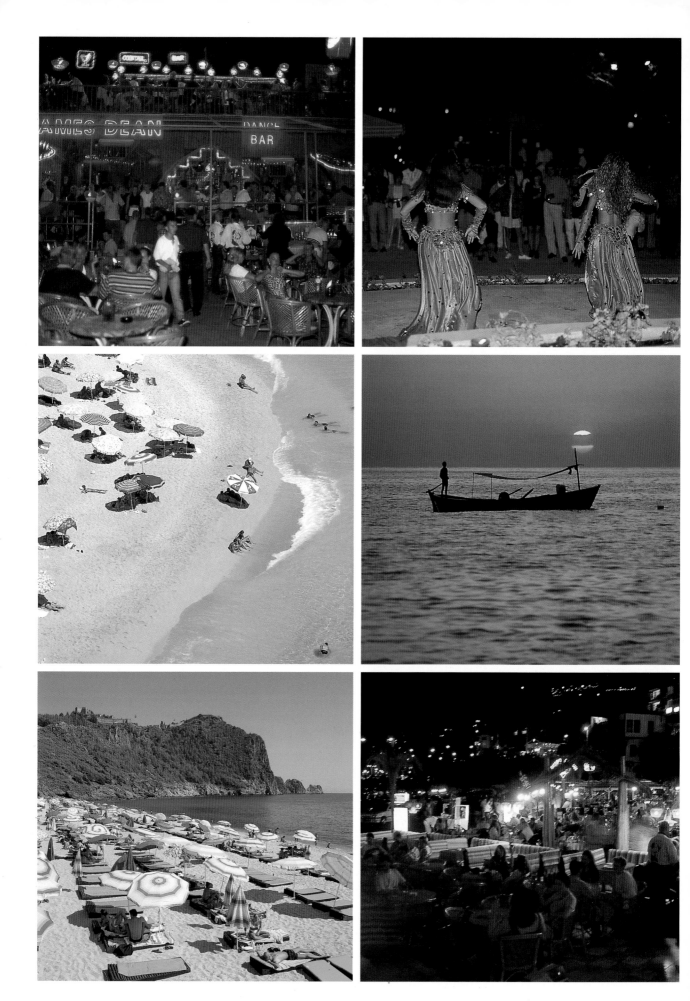

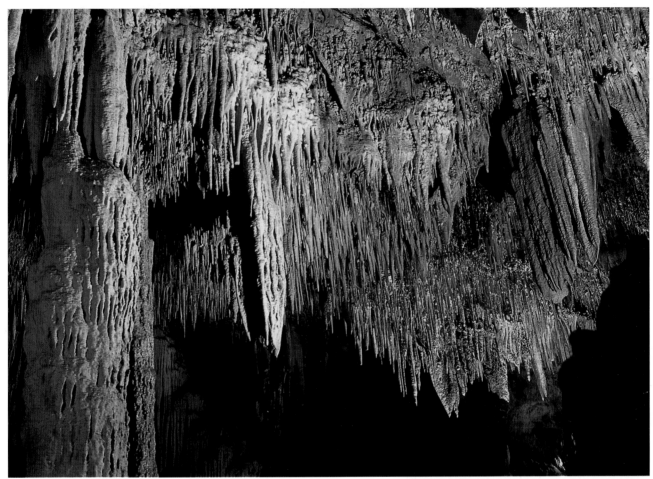

DAMLATAŞ CAVERN

The entrance to the Damlataş Cavern, regarded by speleologists as one of the most interesting caverns in the world, lies at the beginning of the road leading up to the castle.

Visitors never fail to be immensely impressed by the extraordinary colours and play of light produced by the stalactites and stalagmites formed by the calcareous water seeping through the roof.

Experts agree that the humid atmosphere within the cavern is extremely efficacious in the treatment of asthma and special health cures are arranged here.

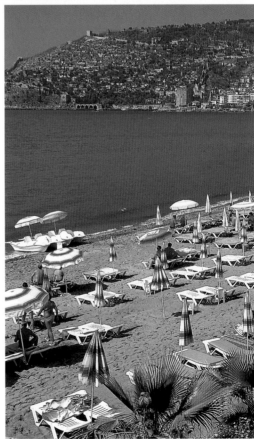

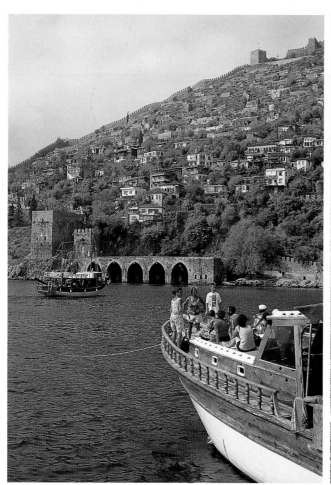
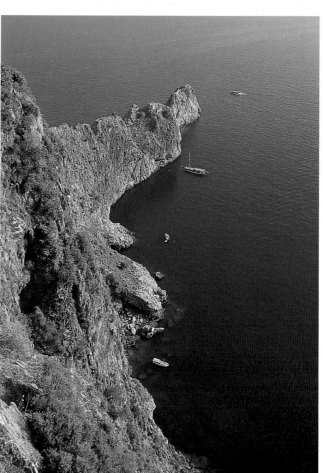
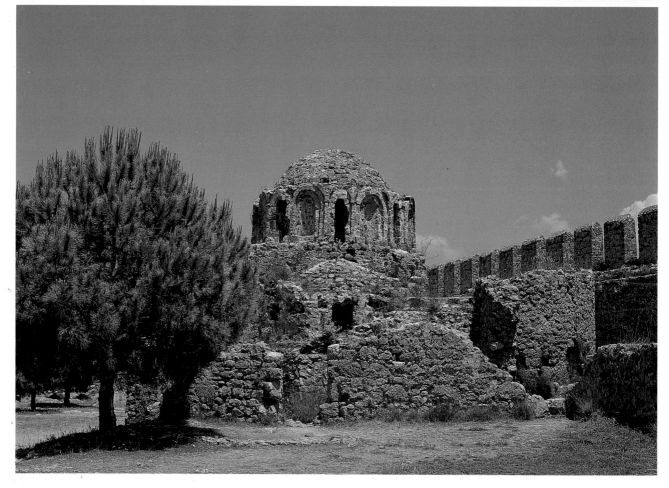

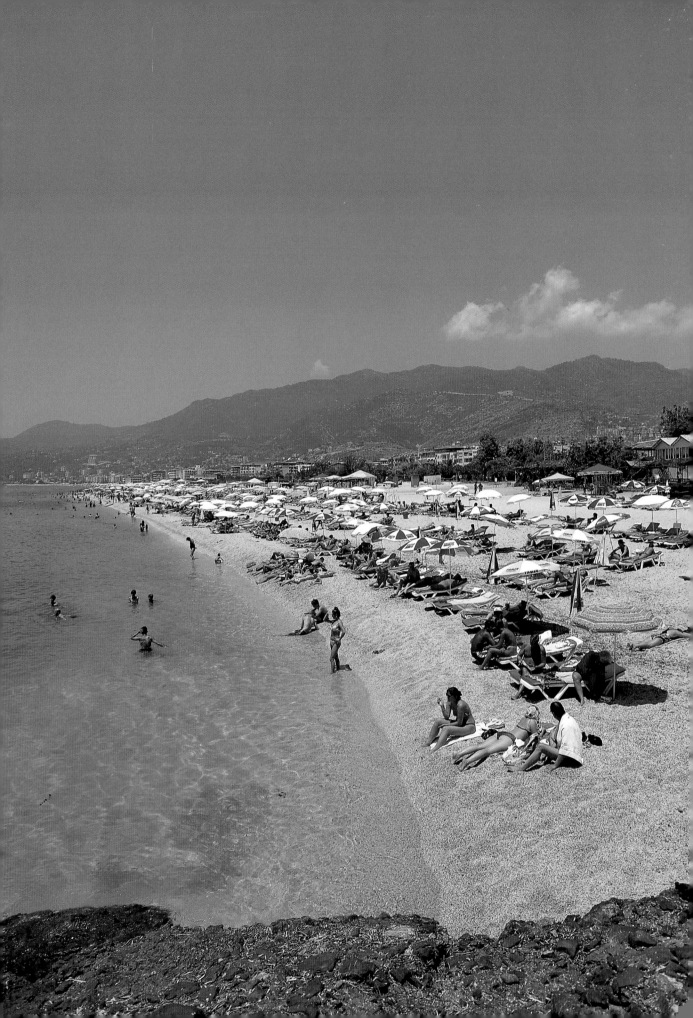

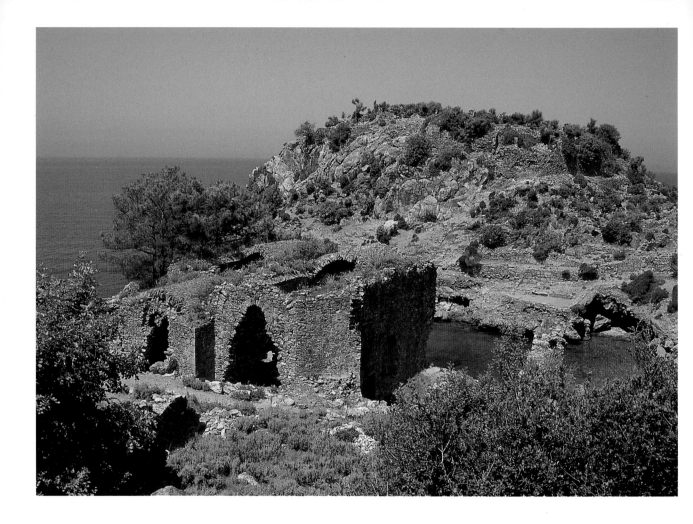

I O T A P E

Situated at a point 33 km along the Alanya-Gazipaşa road, Iotape, though a very small site, is of considerable historical interest. The remains of the city, which was founded during the period of Commmagene hegemony in the 2nd century B.C. and named after the wife of King Antiochus IV, display the characteristics of both the Roman and Byzantine periods.

The acropolis was located on the fairly high promontory and fragments of the walls surrounding it are still visible. In the bay immediately to the east can be seen the remains of two baths, a church and a temple containing an inscription indicating that it was dedicated to the Emperor Trajan.

GAZIPAŞA-SELINUS

The ruins of Selinus, known throughout the Roman world as the city in which the Emperor Trajan died in 117 A.D., are located on the summit and slopes of a hill running down towards the sea to the south-west of the Hacımusa stream and the Gazipaşa beach. On the summit can be seen the remains of a medieval castle with very well-preserved towers and defence walls.

The church and cistern on the acropolis have survived in a very good state of preservation.

Other important buildings include two Roman baths, an agora, an aqueduct and a necropolis.

General view of Iotape.

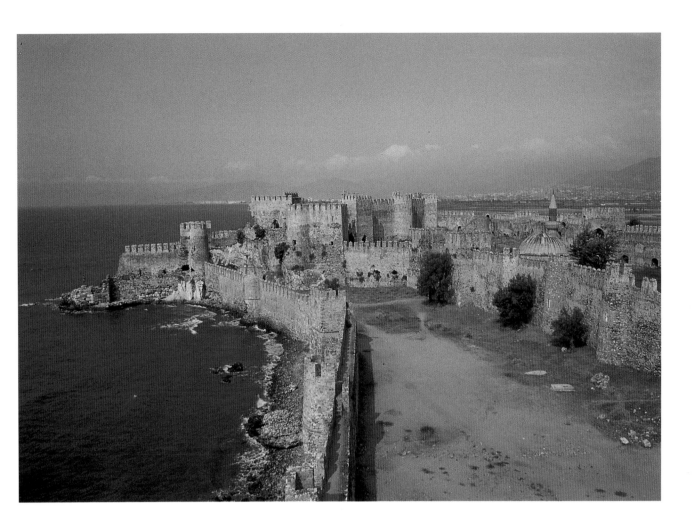

ANAMUR-ANEMURION

Leaving Gazipaşa and travelling for some two or three hours over a distance of 80 km along a winding and rather dangerous, though very beautiful road through a region where the Taurus Mts come very close to the sea, you will arrive at the city of Anamur located in a fertile plain formed and watered by the Anamur River that flows down to the coast from the Taurus Mts. At a latitude of 36^03', the city and cape of Anamur form the most southern point on the Turkish coast. The ancient city of Anemurion is situated immediately to the right of the point where the road from the mountains joins the Anamur plain.

The first settlement on the site occupied by this ancient city, which is now surrounded by banana plantations and greenhouses for vegetables, goes back as far as the 1st millennium B.C. The city, liberated from the Persian yoke with the arrival of Alexander the Great, came under Seleucian hegemony in 322 B.C. In 133 B.C. it was incorporated in the Roman Empire, but was later ceded to Commagene by the Emperor Caligula. During the Byzantine period, which began in 395 A.D., the city was exposed to the looting and pillage of Arab raiders. Finally, in the 12th century, the whole area passed into the hands of the Seljuk Turks.

The site is divided into two sections: the lower and upper city. The upper city, which consists of the acropolis, has interesting remains of a theatre, odeon, bath, basilica and colonnaded street. The lower city has a very interesting necropolis, the third largest and most important necropolis in Anatolia, with two-storeyed tombs over vaulted

structures. There are also interesting remains of a church dating from the Late Byzantine period.

Continuing for 3 kms to the east of Anamur we arrive at the "Mamure Castle". Built in the 3rd century, in the Roman period, it continued to be used in Byzantine times. After its captured by the Karamanid Turks in 1230 the castle underwent extensive repairs. The inner section of the castle contains interesting remains of a mosque and a Turkish bath. Of interest, too, is the wealth of fauna and flora in the moats surrounding the castle, offering the photographer plenty of opportunities for taking fascinating photographs of all tuitles different varieties.

For those wishing to enjoy a wonderful view and take panoramic photographs of the surrounding area, the south tower of the castle is recommended as the ideal point of vantage.

S I L I F K E

Silifke, the centre of ancient Cilicia, was founded by Seleucus, one of the generals of Alexander the Great, in the 3rd century B.C. The famous castle, cellars, cistern and towers built in the 12th century are still well worth seeing. The very interesting remains of the six-arched bridge over the Göksu river immediately adjacent to the city are of very great historical importance. According to the inscription it bears, the bridge was built by Titus and Domitianus, the sons of the Emperor Vespasian. It was in this river that the German Emperor Frederick Barbarossa, the leader of the Third Crusade, was drowned.

The church of Hagia Thekla in Silifke was built in 337 A.D. by Constantine the Great and dedicated to Hagia Thekla by disciples of St Paul.

Silifke, rocks like man.

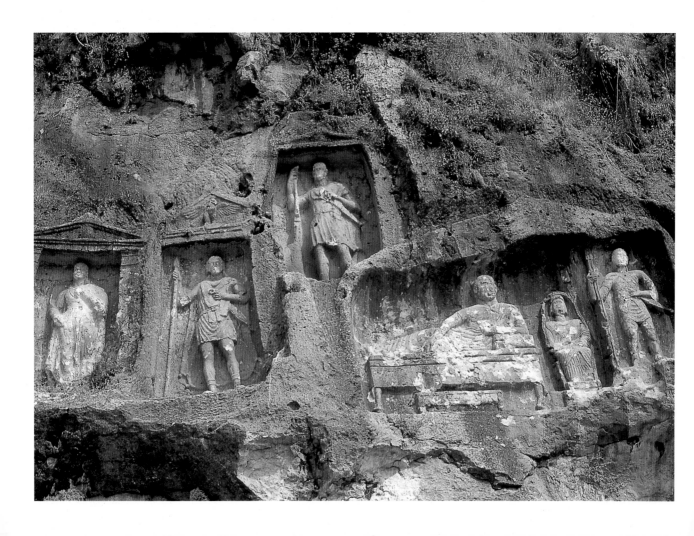

TERMESSOS

As far as geographical location is concerned, Termessos lies, not in Pamphylia or Lycia, but in the province of Pisidia. That is why we thought it would be advisable to stop at Termessos before continuing our journey into Lycia.

Located on wild and rugged slopes amid the peaks of the Taurus Mts and surrounded by a vast necropolis of tombs broken and scattered by a series of devastating earthquakes, Termessos resembles a natural fresco of the Last Judgement that cannot fail to amaze and confound all who visit it.

Celebrated as the only city to withstand the attacks of Alexander the Great, Termessos continues, in the sound of the winds howling around the peaks

Termessos ancient city, theater.

of the mountains, to repeat to tourists arriving from all four corners of the world the wild, warlike and heroic legends of the past.

In the years following their success in withstanding the attacks of Alexander, the inhabitants of Termessos, who, in their inscriptions, refer to themselves as Solymians, indigenous Pamphylian people, engaged in numerous wars with their neighbours, while at the same time earning livelihood from trade in olives, olive oil and fruit.

Termessos enjoyed its first period of peace and prosperity during the Hellenistic era, and its second under the Romans, when the citizens were given the right of drafting their own laws. By the 5th century A.D., however, the city had been emptied of its inhabitants.

The city, which lies 30 km north-west

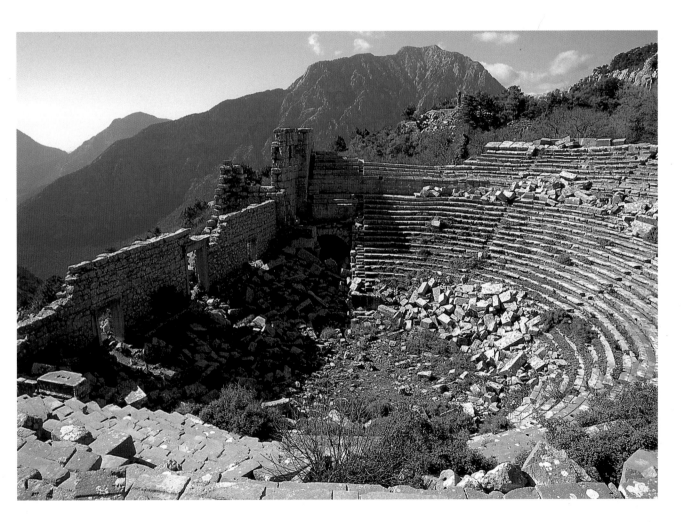

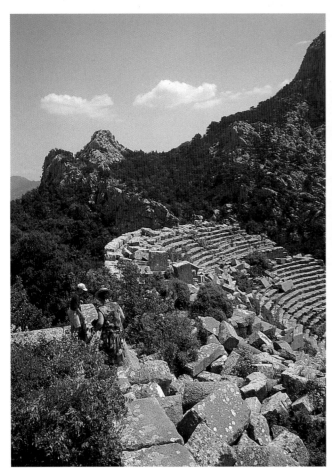

of Antalya, was founded at an altitude of 1050 m on a piece of level ground between two mountains.

The steep, winding road leading up to the site ends in a car-park, and the visitor would be well-advised to rest here a little before attempting the rather difficult and arduous climb up to the ruins. The climb may not be easy, but the reward is well worth the trouble. You can be sure of that!

But before this, as you drive up to the site, you must see fragments of the city defence walls, whose construction dates back to the Hellenistic period but which underwent radical modifications in Roman times.

From the steep road leading up to the site the remains of an aqueduct can be seen lying amidst these walls and various other ruins.

To the left, at the beginning of the ancient track known as the "King's Way",

lies the lower section of the second largest necropolis in Anatolia, while on the right there is a propylon, or monumental entrance to a temple, dating from the reign of the Emperor Hadrian.

Continuing up the slope for some 300 m, you will see the walls of the inner fortifications on the left and, immediately behind them, the remains of a gymnasium. Just at this point a monumental road leads off to the right.

A path winding like a snake through the dense vegetation will take you through the portico of Attalus II, of which only the foundations survive, to an agora containing five large cisterns hollowed out of the rock.

A path branching off to the left will lead you to the theatre, and the unique and extraordinary beauty of the building and its location will immediately make you forget the arduousness of the climb. This little Hellenistic theatre, set like an

Termessos ancient city, theater.

Termessos, olive oil storage.

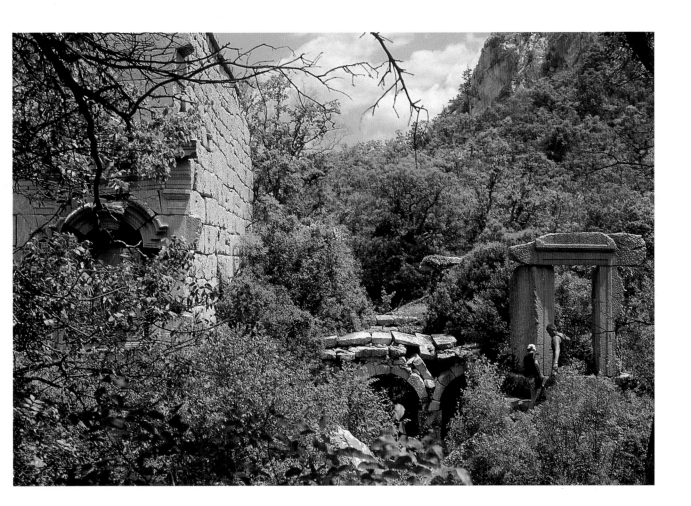

Termessos ancient city, necropolis.

eagle's nest in a hollow between two precipitous slopes overlooking the Mediterranean from an altitude of many hundreds of metres, is as lovely as the most precious jewel. The section to the right of the stage building added in Roman times contains a "Royal Box" or loggia for the local dignitaries.

Immediately beside the theatre there is a bouleuterion in the form of a small odeon used for meetings of the city council.

This section, with the ruins of a temple scattered around it, possesses a certain divine magnificence. Immediately behind the auditorium of the theatre stands the temple of Zeus Solymeus, with walls of some 4 m in height, and, in the lower section, a temple of Artemis with an inscription over the door to the effect that the temple was built by a woman by the name of Aurelia Armasta with her own expense and that the cult statue was

made with the financial assistance of her husband.

Immediately beside this are to be found the remains of a largely ruined Doric temple dated to the 2nd century. One can also see a Corinthian "templum in antis" dating from the Antonine period (2nd century A.D.)

Returning to the agora and following a path past the ruins of a Roman house on the left hand side, you will find yourself surrounded by a dazzling wealth of historical remains, the whole area being covered with hundreds of sarcophagi, temple-type tombs and funerary monuments of all varieties.

Some of these are adorned with reliefs, and one of these, that of a horseman, is said to depict Alcestas, one of the generals of Alexander the Great.

L Y C I A

The region in the south-west corner of Anatolia known in ancient times as the province of Lycia contains some of the loveliest and most interesting historical sites in Turkey, together with a whole line of beaches and beauty-spots, each more attractive than the other, to which every visitor is eager to return.

Lycia consisted of the region jutting out into the Mediterranean between Antalya and Fethiye now known the Teke Peninsula, in which the mountains of the Taurus range rise to a height of 2,500 m. The province of Pamphylia lay to the east and the province of Caria to the west.

Lycia differs from the other provinces insofar as the cities were founded not by invaders but by the indigenous people of the region, a fact which is proved linguistically by the suffixes "-nd", "-nt" and "-ss" at the end of the place-names, suchas in Cadyanda, Arycanda,

The ancient city of Tlos.

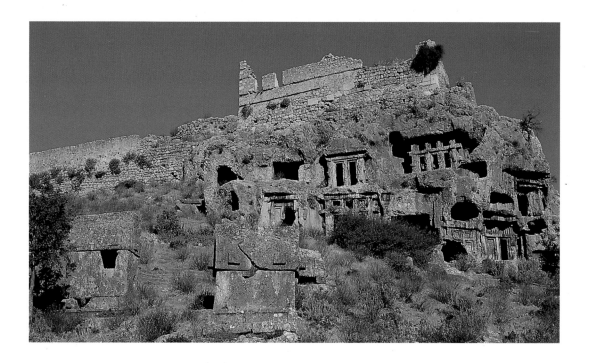

Termessos and Ibedessos. Egyptian and Hittite sources refer to the inhabitants of the region as "Lukka", who are mentioned as having fought with the Hittites against the Egyptians at the Battle of Kadesh in 1295 B.C.

Other sources give the names "Lubi" and "Leleg". Celebrated for their warlike character and passionate love of freedom, the Lycians offered fierce resistance to all attempts at invasion.

This is confirmed by Homer's reference to the Lycians in the Iliad, where he describes how the heroes Sarpedon and Glaucus joined Hector in defending Troy against Achilleus and Agamemnon.

The history of Xanthos gives further convincing evidence of the heroic resistance offered by Lycia to all invaders.

Views from the ancient cities of Sidyma and Patara.

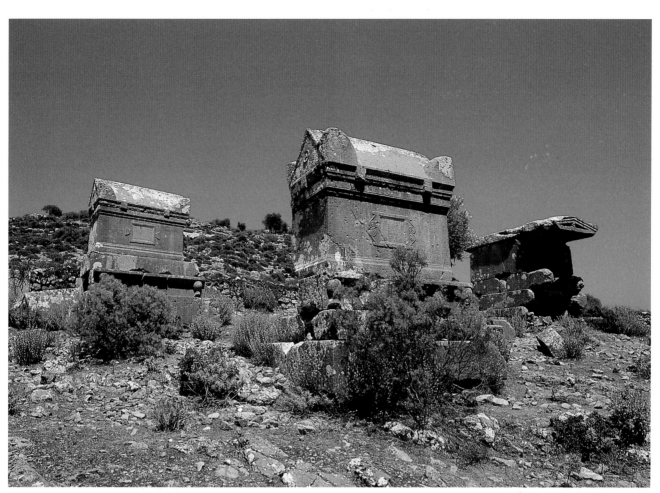

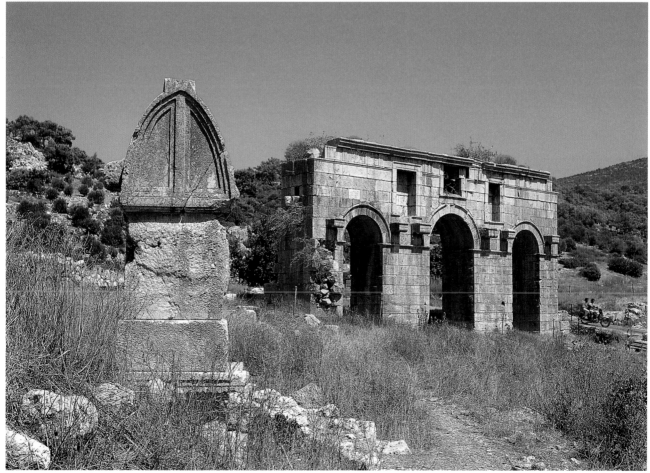

K E M E R

The Antalya-Finike highway runs along the coast through the Beldibi tunnels to Kemer.

On emerging from the Beldibi tunnel one can see on the right hand side a very interesting rock shelter known as the Beldibi Cavern. This was already inhabited in the Mesolithic period and pictures drawn by the people who inhabited the cave at that time are still visible on its walls.

The cavern is now under conservation. After passing through the village of Beldibi the road makes its way through the village of Göynük, with its citrous orchards and rows of luxury hotels and holiday villages, to reach Kemer, one of the most important tourist centres in the region.

Actually, the name "Kemer' is used to cover the whole area around the village of Çamyuva, the main centre of tourism not only in Antalya but in the whole of Turkey.

Kemer is a touristic paradise of extraordinary beauty, with beaches of glorious sand washed by the cleanest and clearest waters in the Mediterranean, continually purified by the deep currents. With its holiday villages, hotels, motels, pensions, restaurants, cafés, bars, night-clubs, discos and shops selling everything under the sun, not to mention its unique local colour, Kemer is a centre that every tourist must certainly visit and, preferably, spend at least a few days in.

Motor-boats can be hired for a tour of the area by sea and visit to the other bays and beaches.

Kemer is a paradise for tourists.

Kemer, Moonlight Park and the beach.

General view of Kemer.

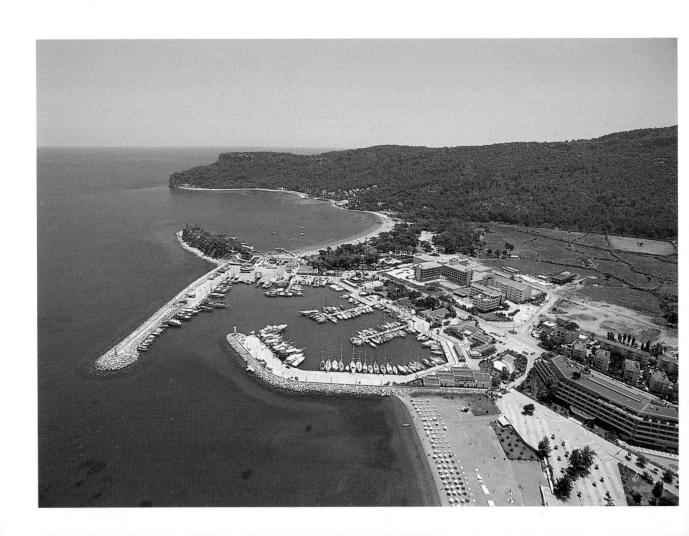

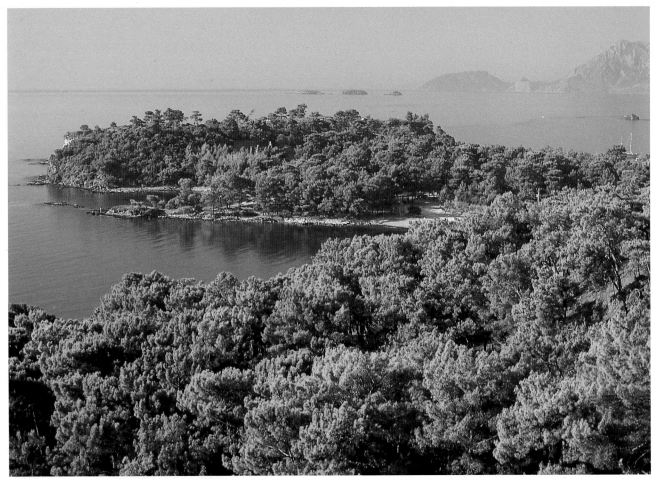

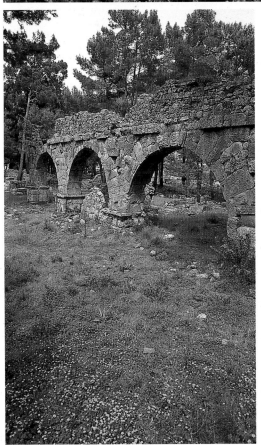

PHASELIS-TEKIROVA

Where in the world can you find the most marvellously unique combination of sea, forest and history? There is no doubt about the answer: Phaselis! The conversion of the area into a National Park has freed Phaselis from the blight of touristic exploitation and transformed the whole area into an earthly paradise.

Located in a particularly beautiful setting, Phaselis was founded in the 7th century B.C. by Rhodian colonists arriving in the area under the leadership of a commander by the name of Lakaios. The foundation of the city was immediately followed by a period of Persian rule, and, although Phaselis, being joined to the Delian Confederacy against the Persians, regained its independence as the result of a naval

Phaselis, ancient city. General view.

The aquaduct of Phaselis.

A view from Phaselis ancient city.

Phaselis, Western harbor.

Theater, Phaselis ancient city.

68

expedition led by the Athenian commander Cimon in 449 B.C., Phaselis was soon forced once again to recognise Persian hegemony. It was one of the cities that offered an exceptionally warm welcome to Alexander the Great when he arrived here from the siege of Termessos, and it is in Phaselis that he is known to have had his wounded soldiers tended and to have spent the winter months. After that, the city changed hands several times between the Ptolemies and the Rhodians until it finally achieved independence in 160 B.C. After remaining for some time as a pirate stronghold ruled by the famous Mediterranean pirate chief Zenicetes, the city later passed into the hands of the Romans, and it was under the "Pax Romana" that the city was to enjoy the most brilliant period in its history. A monumental arch was

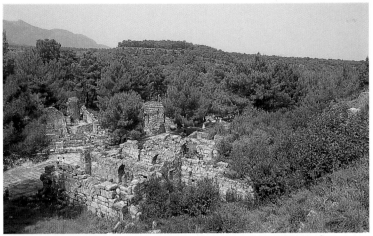

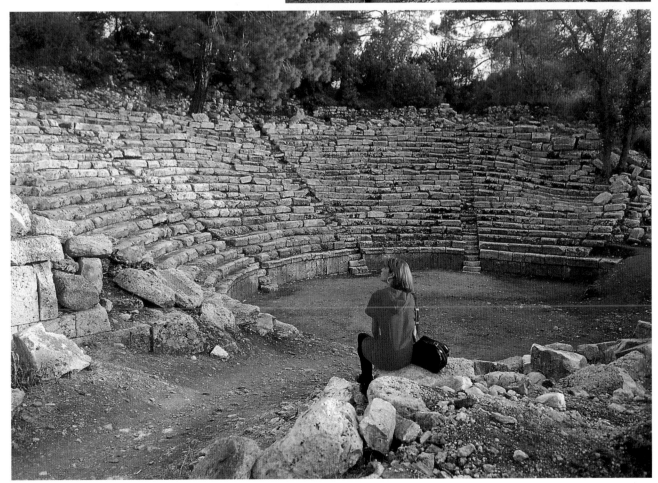

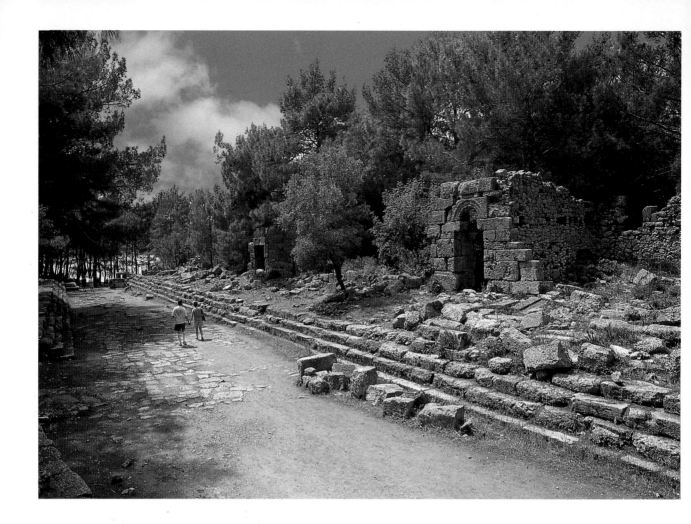

erected during a visit to the city by the Emperior Hadrian in 129 A.D.

The three bays surrounding the peninsula on which Phaselis is located provide the city with a north, a middle and a southern harbour. The city is entered under the very well-preserved aqueduct beside the eastern harbour. In the southern harbour, the smallest of the three, one can still see the ancient breakwater and embankment of cut stone.

That this harbour was used for military purposes is obvious from the remains of the defence walls and fortification towers. From here one follows a monumental way or colonnaded street on which are to be seen the remains of two Roman baths and three small agoras, the largest of which was built by Domitian in the 1st century A.D.

In both of the baths one can see the round brick columns peculiar to the "hypocaust", the famous heating system employed in Roman baths. Half way along the monumental way, on a piece of raised ground to the left, stand the ruins of the theatre, while at the end of the street we find the ruins of the Hadrianic gate, marble blocks from which, with reliefs displaying cornucopias, clusters of grapes and a wealth of detailed decoration, can be seen scattered over the ground. From the Gate of Hadrian we arrive at the western harbour situated in the largest of the three bays and containing a beach of quite extraordinary, spell-binding beauty.

We strongly advise you to climb up to the top of the theatre and the summit of the hill which once formed the acropolis. From there you can enjoy a marvellous view over the three harbours and the whole of the surrounding area.

A view from Phaselis ancient city.

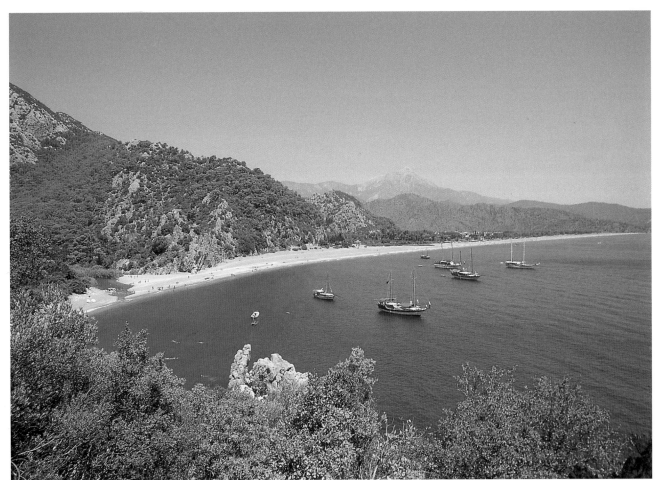

Coast of Olympos ancient city.

A view from Olympos ancient city.

OLYMPOS

Shortly after leaving Phaselis, the road arrives at Ulupınar, and then, after passing through forests of red pine, we are suddenly confronted by a cluster of plane trees. This is a well-known stopping place with rich springs, restaurants and other facilities. At a point 2 km past Ulupınar a road branches off to the left and makes its way down the valley to the village of Çıralı. Until recently the village was served by a very poor road, with the result that so far there has been very little touristic development and Çıralı remains a very charming village with almost all of its original, authentic character intact.

The road crosses a bridge and continues along the stream until it reaches the shore. To get to the ruins of the ancient city of Olympos one must

cross the stream again and proceed for some way towards the right. There is no difficulty in crossing the bed of the stream in summer as at that time almost all the water is used for the irrigation of the vegetable gardens and the stream is quite dry, but in spring, when the stream is swollen by the water from the melting snows, crossing can be quite difficult. Once across the stream, a walk of about 1 km along the broad sandy beach will take you to the site.

The ancient city was founded on both banks of the stream in the deep valley behind the bay. According to Strabo, it derived its name from the imposing mountain on the slopes of which it rests. Olympos became a member of the Lycian League in the 2nd century B.C., but its importance as a commercial port attracted the attention of the pirates, who soon succeeded in capturing it. After the seas were cleared of pirates by the Romans, the city developed very rapidly, entering upon a period of great wealth and prosperity. During the Byzantine period, however, Olympos rapidly declined in importance and gradually fell into oblivion, a forgotten city hidden away amid dense vegetation.

Turning away from the sea and entering the valley you will see on the hill to the right the defence walls that once surrounded the acropolis. At the point where the southern slopes of the acropolis meet the valley lie two sarcophagi, quite recently unearthed and now under conservation. One of them, remarkable for its inscription and the relief carving of a ship, would appear to have belonged to a sea captain by the name of Eudemos, whose life is related in verse, with philosophical references to the many dangers to which he had been exposed.

The monumental door to be seen a little further along the valley belongs to the cella wall of an Ionic temple dated

Two Views of Olympos.

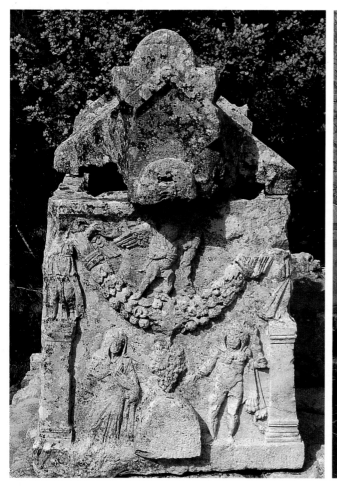

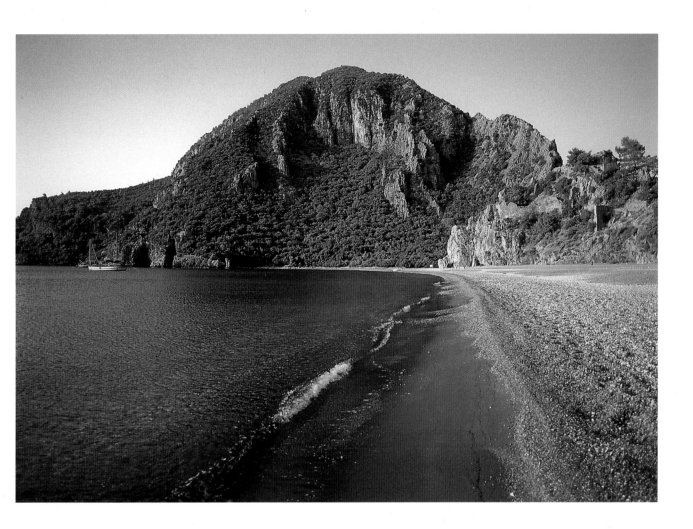

A very beautiful view from Çıralı coast.

from the reign of Marcus Aurelius in the 2nd century A.D. The door rises to a height of nearly 8 m and is flanked by consoles. The remains of a late Roman bath are to be found to the north-east of the temple. To the south of the river bed there is a monumental way or colonnaded street nearly 11 m in width. On this point, there are two agoras built during the reigns of Domitian and Hadrian. Near the river, towards the south, there is a bath building displaying almost all the characteristics of a traditional Roman bath. The small theatre on the slope of the hill is in a very ruined state.

On the left of the valley, which now broadens out and is covered at the present day with citrous plantations, lies the necropolis of Olympos, in which monumental tombs and sarcophagi can be found lying side by side.

ÇIRALI-CHIMAERA

The Chimaera appears in the story of Bellerophon and the Chimaera, one of the most fascinating of mythological fables. According to Homer, Bellerophon was the son of Glaucos of Epirus.

Anteia, the wife of Proitos, king of Argos, fell in love with Bellerophon but, furious at finding her love rejected, she falsely accused the young man to her husband. Greatly angered, the king sent Bellerophon to the King of Lycia with a sealed letter containing a request that he should be put to death.

Bellerophon showed quite extraordinary power and skill in evading every attempt to kill him, and the king was so impressed that he arranged a marriage with his daughter, which resulted in the birth of two children.

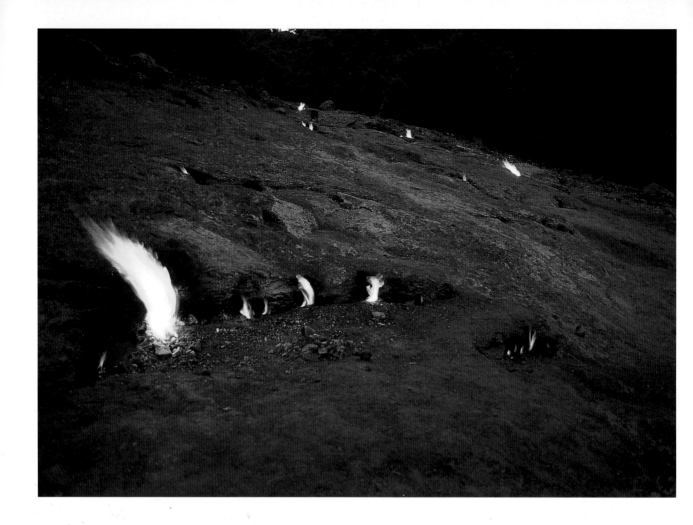

During a visit to Corinth, Bellerophon met the goddess Athena who, greatly impressed by the heroic character of the young man, presented him with a magic bridle.

Mounted on Pegasus, the winged steed he had tamed by means of Athena's magic bridle, Bellerephon attacked and killed with his arrows the mythological monster with the head of a lion, the body of a goat and the tail of a snake known as the Chimaera.

The fire springing from the ground at this point is supposed to consist of the flames issuing from the mouth and nostrils of the monster.

Returning by the way we came, from Çıralı we follow the road behind the village whence, after a journey of some 5 km, we arrive at the head of a broad valley. Here we leave our transport and continue on foot up the path leading to the Chimaera, arriving, after a fairly easy climb of about half an hour, at a bare, rocky clearing of about 1,000 m² surrounded by thick forest vegetation. Those arriving here for the first time are amazed to see flames springing out of the ground.

This extraordinary phenomenon is caused when the natural gas from underground sources comes into contact with the oxygen in the atmosphere and bursts into flames. In ancient times the site was occupied by a sanctuary dedicated to Hephaestus (Vulcan), and, in the Byzantine period, by a small church. A careful search amid the thick vegetation with which the remains of this church are now overgrown will reveal a number of very interesting frescoes.

Çıralı, flames of natural gas.

74

FINIKE

The first important place we arrive at after returning to the main road and continuing on our way along the coast from the direction of Antalya, is Finike, celebrated for its lovely sweet juicy oranges.

After passing through an area filled with orange groves and greenhouses supplying early vegetables to the cities, we arrive at ancient Phoenicus, a place well worth a visit, with a yacht marina, cafés along the shore and a very fine beach. Unfortunately, the ancient city is buried under the foundations of the modern settlement, but if you feel hot and dusty after your exploration of Olympos and Çıralı you will have the opportunity of refreshing yourself in the very fine and very famous Turkish bath.

And don't forget to treat yourself to a large glass of orange juice, full of vitamins and available in every season of the year.

LIMYRA

About 8 km from Finike you will come to a necropolis scattered here and there with Lycian tombs, most of which date from the 4th century B.C., together with a certain number of Roman tombs adorned with reliefs.

Leaving the necropolis and making your way through the ruins of the

Beautiful in lets around Finike.

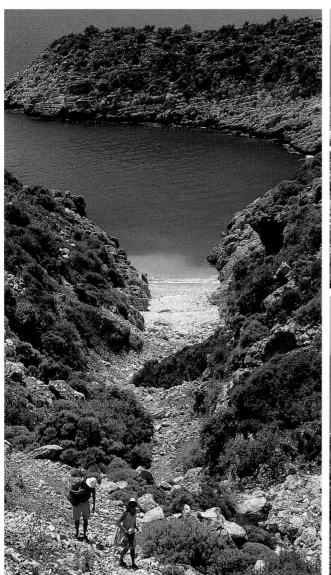

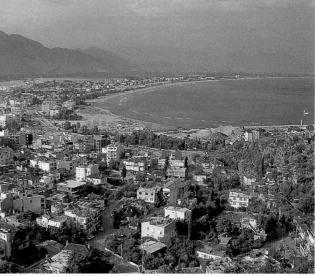

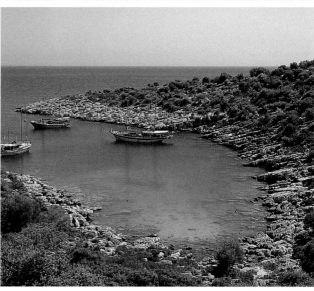

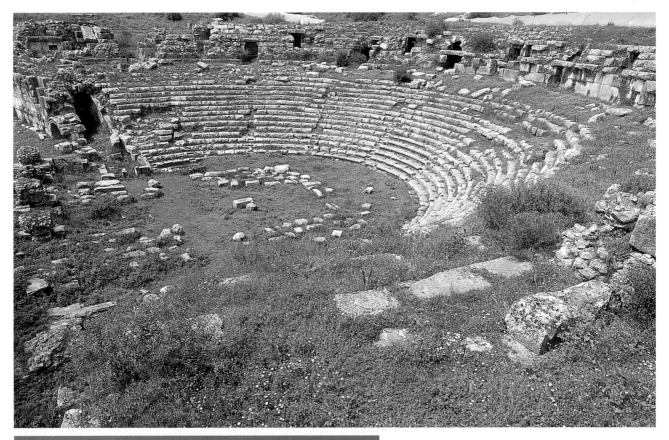

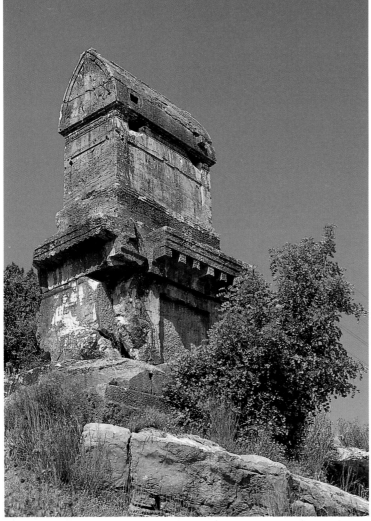

Byzantine defence walls you will arrive at a square, monumental tomb. This is very probably the tomb of Gaius Caesar, grandson of the Emperor Augustus, who died in Limyra in 4 A.D. as a result of wounds received in a battle against the Parthians.

Immediately beside the road stands a small ancient theatre which has been partially restored. To the left of the theatre there is a sanctuary consisting of hollows in the rock and dedicated to the twelve Lycian gods.

In the eastern section of the site can be seen the ruins of a basilica constructed in the 5th century A.D. The plan of the building immediately adjacent to it very closely resembles a the bishops' palaces of the same period, which suggests that the basilica may have been the Limyra cathedral.

Theater, ancient city of Limyra.

Mausoleum of Xatabura, Limyra.

ARYCANDA

The ruins of the ancient city of Arycanda are located within the village of Arif about 27 km from Finike at the meeting-point of the Lycian coastal cities and the cities of the inland region.

From evidence provided by the extant coins it would appear that the city was founded in the 5th century B.C. and that it joined the Lycian League in the 2nd century B.C.

After the establishment of Christianity the city remained until the 11th century the seat of a bishopric.

The acropolis is situated on a small hill to the south of the city on which fragments of the defence walls are still visible.

To the east of this lie the remains of a bath and a gymnasium, and, immediately behind this, the eastern necropolis. Another interesting monument in the vicinity of the gymnasium is the temple tomb with podium, while another tomb with relief carvings can be seen 30 m to the south.

An agora, odeon, theatre and stadium are located on the terraces to the north of the eastern necropolis. In the centre of the agora are the remains of a temple or altar. The upper part of the agora would appear to have been surrounded by colonnaded courtyards.

The Arycanda theatre is almost wholly Hellenistic in style and would appear to have undergone no modifications in the Roman era, any repairs having been carried out in strict conformity with the original form. The cavea, orchestra and stage building have been unearthed in recent excavations.

A flight of steps leads from the theatre terrace to a stadium some 80 m in length, immediately adjacent to the remains of a nymphaeum, a second bath, a stoa and a bouleuterion.

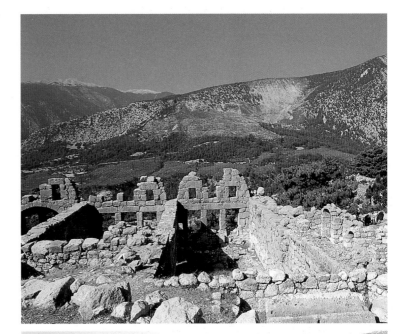

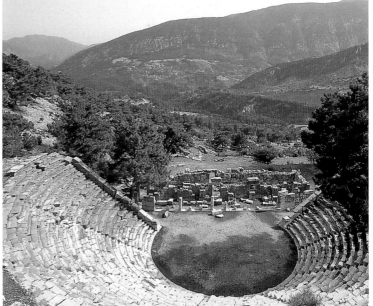

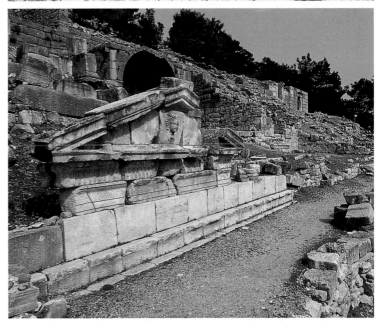

Different views from Arycanda ancient city.

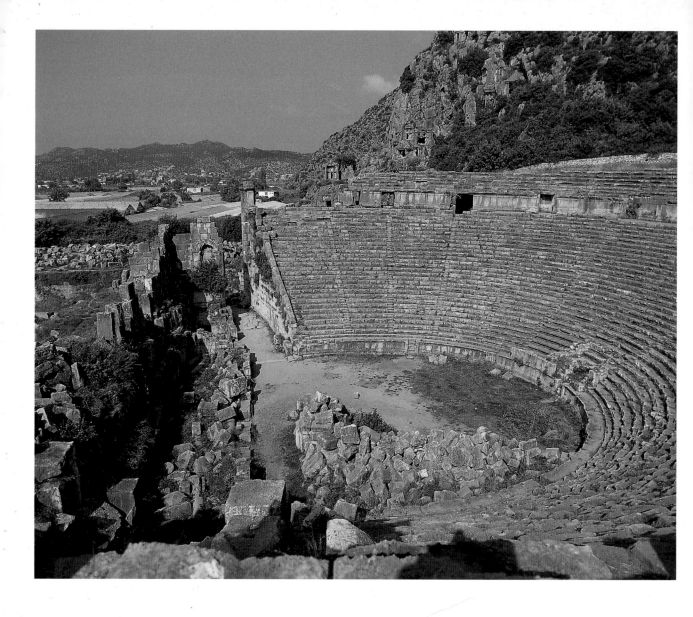

K A L E - M Y R A

From Finike the road winds its way along past a series of bays, each more beautiful than the other, and each with beautifully clear, limpid blue water, to reach the ancient city of Myra, the present-day Kale. Also known to the local inhabitants as "Demre", the settlement was founded on the plain formed by the alluvium brought down from the Taurus Mts by the stream now known as the Demre Çay, but known in ancient times as the Myrus.

According to Strabo, Myra was one of the six most important cities in the Lycian League. It played host to a number of distinguished personalities in the course of its history, including Germanicus, the adopted son of the Emperor Tiberius, and his wife Agrippina (17 A.D.), St Paul, who met some of his disciples here on his way to Rome and, in the 2nd century A.D., the Emperor Hadrian.

The city, like the other cities in the region, showed considerable growth in size and wealth during the Roman period, and by the reign of the Byzantine Emperor Theodosius II it had become the capital of the province and the most important city in the region. St Nicholas, who lived here in the 4th century, became a legendary figure on account of the generous assistance he offered to children, mariners and the destitute, and,

The marvelleous theater of Myra.

Myra, Rock-cut.

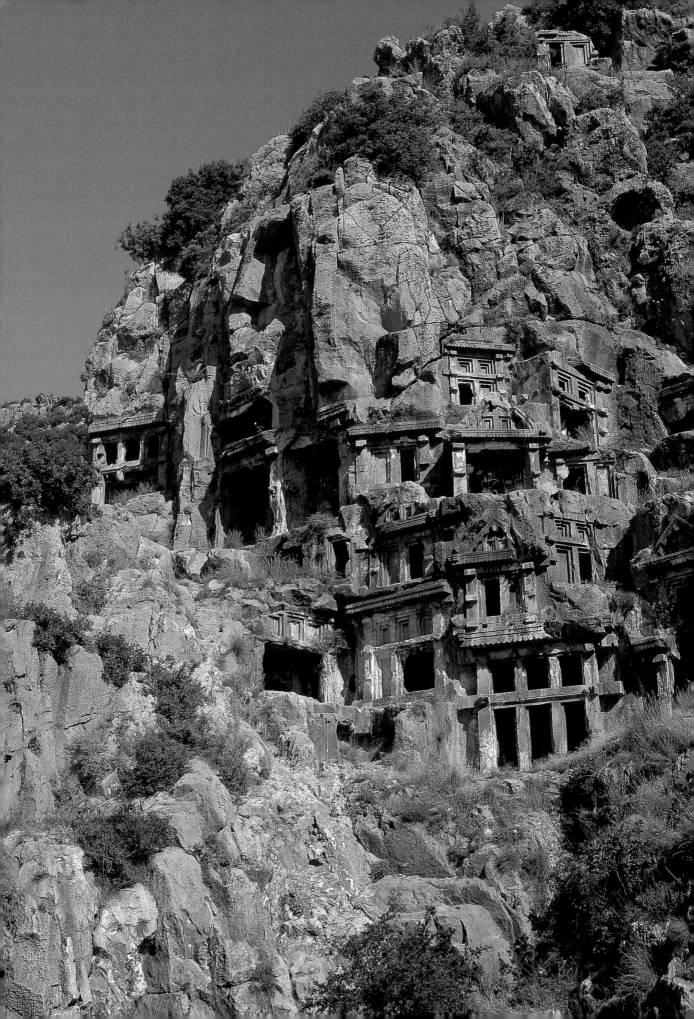

as Santa Claus, became a celebrated figure throughout the whole world.

Like almost all the Mediterranean coastal cities Myra, declined in importance as a result of the Arab raids of the 7th century, and was finally abandoned by its population on its gradual submersion under the mud and alluvium brought down by the Myrus. A careful examination of the ground in front of the stage building of the theatre shows a layer of silt and alluvium some 5 m in depth.

The most important of the buildings in the ancient city of Myra is undoubtedly the theatre. This imposing edifice, dating from the Roman period and with a seating capacity of 10,000, is remarkable for the extremely solid technique employed in its construction and the harmony of its proportions. The orchestra is surrounded by a high wall, which suggests that it was also used for gladiatorial combats and wild beast shows. There are interesting figures of dolphins carved on the edges of the seats.

The rock tombs to be seen on the mountain slope to the left of the theatre, most of them dating from the 5th century B.C., have become the symbol of Myra. These tombs, entirely hollowed out of the rock, are carved in such a way that it produces the impression of round tree trunks. The craftsmen responsible for these masterpieces of tomb architecture have skilfully transferred the Lycian tradition of timber construction.

Visitors cannot fail to be fascinated by the imposing appearance of these tombs, each carved beside or above and below the other, and some of them adorned with reliefs of warriors.

Myra, ancient city, Lycian type of rock-cut graves.

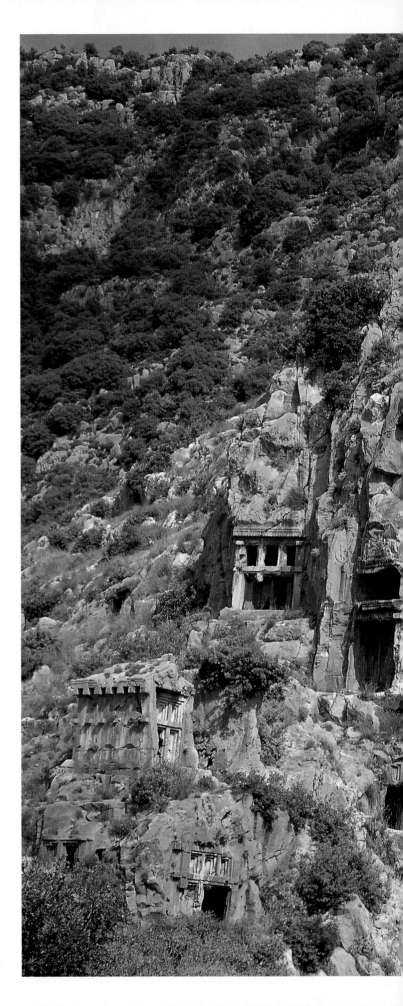

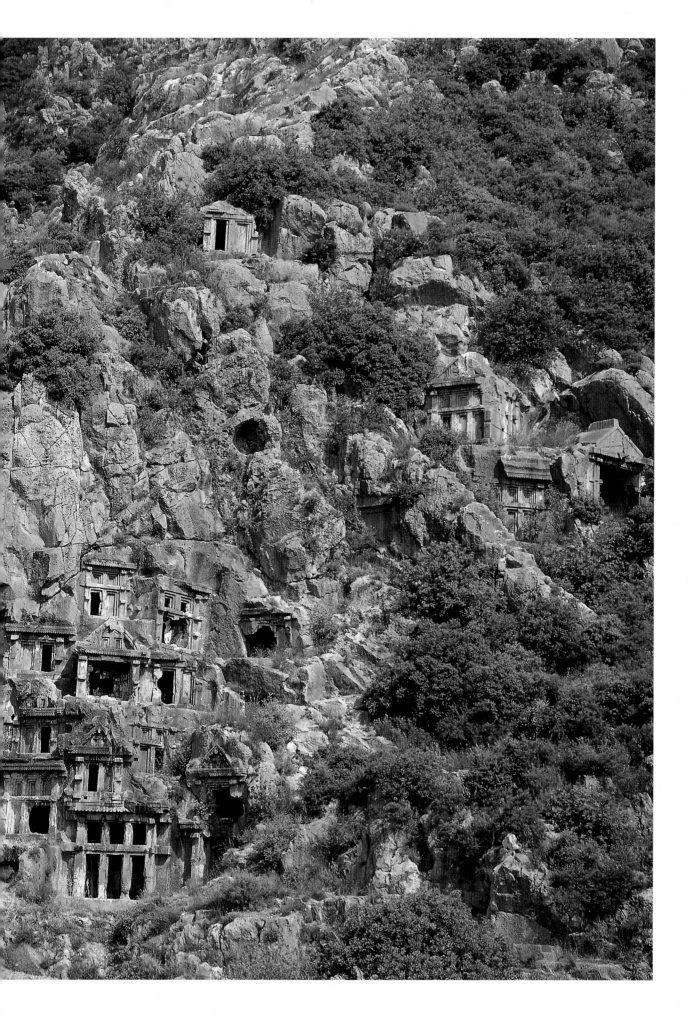

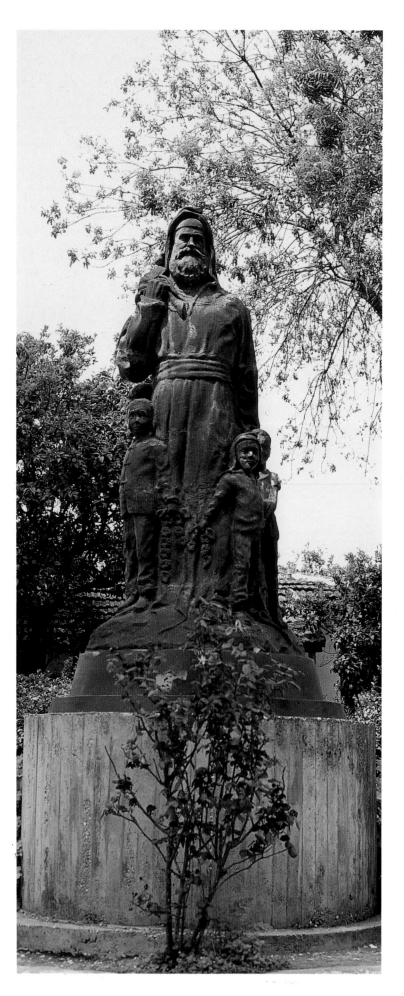

CHURCH OF ST NICHOLAS (SANTA CLAUS)

One of the most important touristic sights in Kale (Myra, Demre) is the Church of St Nicholas, popularly known as the "house of Santa Claus".

St Nicholas, Bishop of Myra, was born in Patara, one of the most interesting ancient sites in Lycia, around 300 A.D. Well known for his philanthropy and benevolence, he became a legendary figure on account of the help and assistance he offered to orphans and the destitute, and, after his death, was generally recognised as a "saint". St Nicholas won the love and affection of children by the surprise visits he paid them and the small gifts he brought. He owed his appointment as Bishop to the zeal and success he had shown in the spread of Christianity in the region and was buried in the church bearing his name. It was in this church that he lived and worked for many years, investing it within a more unusually sacred character.

His fame spread throughout the whole of Christendom and even now he is still known and loved as the patron saint of children and mariners. It goes without saying that no tour of Lycia could be regarded as complete without a visit to the church of St Nicholas.

The first church, built here in the 4th century, was destroyed by an earthquake shortly after Nicholas' death, but, as Myra had now become an important Christian centre, work was immediately begun on the construction of a new basilica. This church suffered extensive damage in the Arab raids of the 7th and 8th centuries and, in the 11th century, some Italian merchants arrived here, broke open the sarcophagus of the saint and carried his

Statue of St. Nicholas (Santa Claus) in the garden of the church of St. Nicholas.

Icons of St. Nicholas (Antalya Museum).

Church of St. Nicholas.

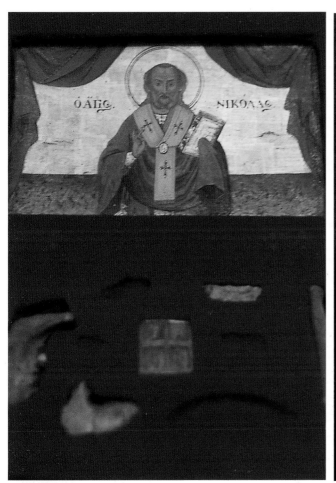

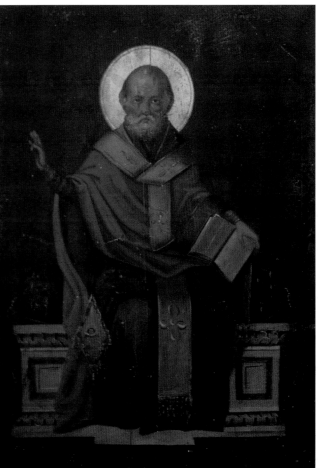

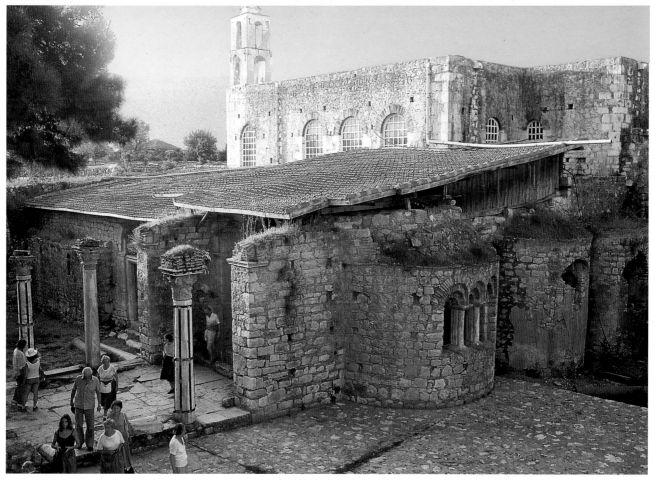

remains off to Bari. A few bones said to have belonged to his skeleton are exhibited in the Antalya Archaeological Museum.

In the 12th century the basilica was repaired, or rather completely rebuilt, by the Byzantine Emperor Constantine Monomachos and his wife Zoë and the roof of the church surmounted by a dome.

The tolerant attitude of the Turks and the local population towards alien religious beliefs ensured that during the Seljuk period no damage was inflicted on the church, which continued to be used as a place of worship.

However, in the course of the centuries, the whole area, including the church, was gradually submerged under the alluvium brought down by the Myrus, and technology was not then sufficiently advanced to permit the removal of the silt accumulation. Even today, the church is surrounded by a layer of alluvium to a depth of 5-6 m. In the 18th century, the church was restored by a wealthy lady belonging to the Russian Orthodox Church with the co-operation a few of the local peasants, and the dome, which had collapsed, was replaced by cross-vaulting. Restoration work has recently been resumed under the auspices of the University of Istanbul.

The building is constructed on the traditional basilica plan with inner and outer narthexes and a main nave with two side aisles on each side. The south aisle contains sarcophagi displaying distinctly Roman characteristics. On the floor of the aisle to the south giving access to the nave and, at the present day, to the church as a whole, one can see very fine mosaic pavements with geometrical motifs.

The church itself, the orange groves surrounding it and the large bronze statue in the garden, all produce a feeling of peace and tranquillity.

One of the three sarcophagi of St. Nicholas Church.

St. Nicholas Church, interior views.

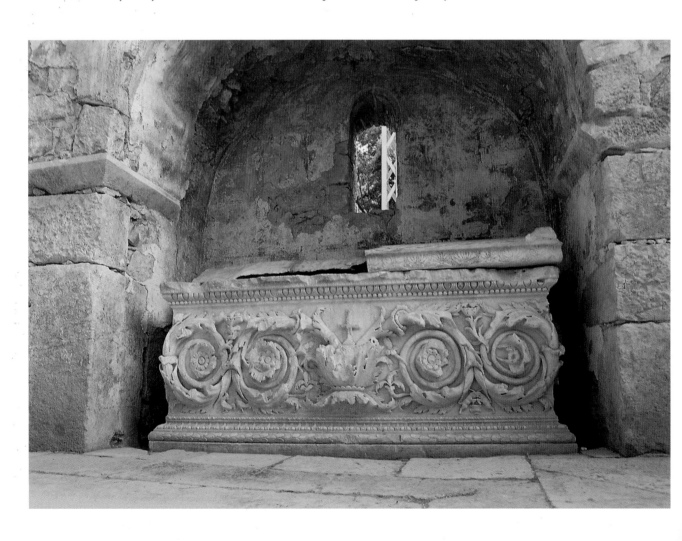

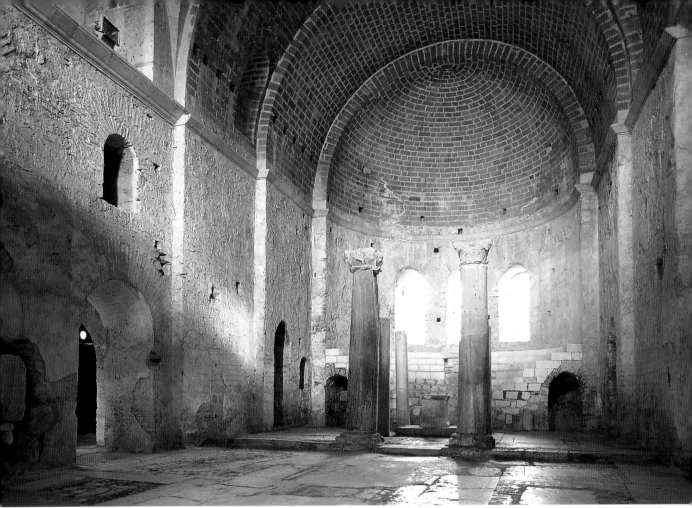

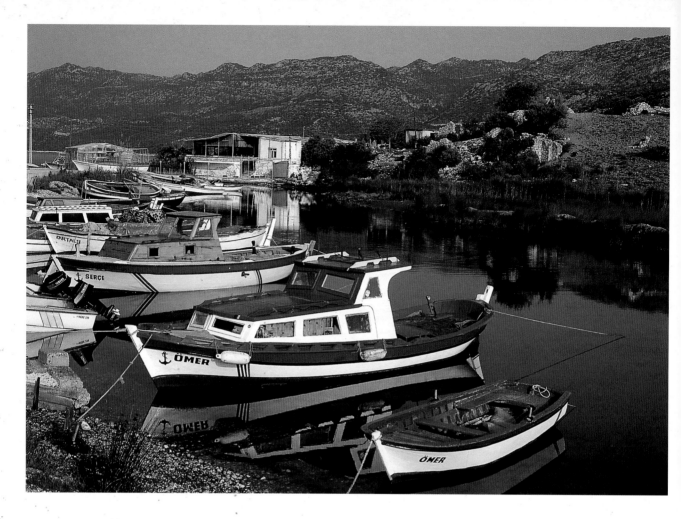

ÇAYAĞZI-ANDRIACE

Çayağzı, the starting-point for boat trips to Kekova, is located on the site of the ancient city of Andriace, whose where the harbour once served to link the Myra and the province of Lycia to the Mediterreanean.

The Andracus, a river famous for its gray mullet, flows through the centre of the valley to empty into the sea in the middle of the beach. The ruins of a large ancient monument to be seen amid the olive trees on the slope behind the marshy ground on the left hand side of the road belong to an eight-roomed granary, measuring 32 x 65 m, erected during the reign of Hadrian. In this "Granarium", or warehouse, were stored the olives, olive oil, wine and timber brought to Andriace from the surrounding countryside, which formed, together with wheat, the main exports of the region. The Granarium in Andriace is the largest building of its type in the province of Lycia and provides clear evidence of the importance of the ancient port and its commercial potential.

The ruins to be seen just before one arrives at Çayağzı belong to the nymphaeum, or ornamental fountain. One can also see the remains of a bath dating from the Roman period. The fresh water spring in the Andriace harbour still retains its ancient importance, and it is from here that inhabitants of Demre obtain their supply of drinking water. The waters from the spring flow into the harbour, providing for the needs of the large numbers of wild birds that live in the neighbouring marshes.

Visitors who have any time to spare should take advantage of the large and very beautiful beach at Andriace with its

A typical view of Çayağzı.

An unique view of Theimussa (Üçağız).

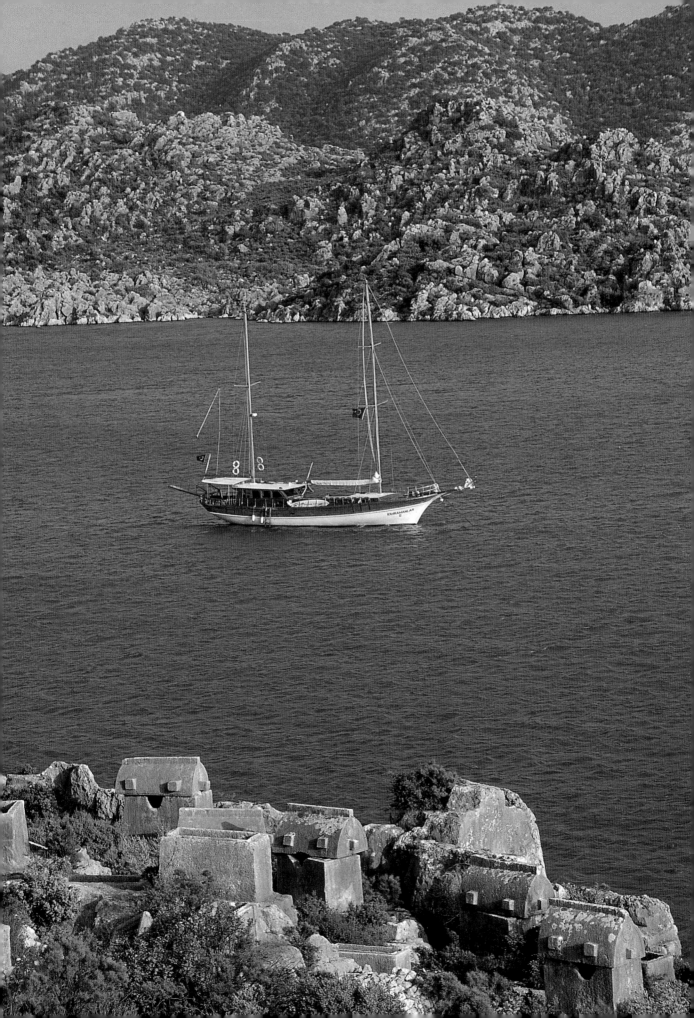

lovely fine sand and crystal clear waters. The sea is very shallow owing to the large amount of alluvium and is perfectly safe for children.

KEKOVA NATIONAL PARK, SIMENA AND TEIMEIUSSA

One of the largest national parks in the province of Antalya, the Kekova National Park comprises a natural and archaeological site extending westwards from Çayağzı. The Kekova trip in Turkish type wooden boats starting off from the harbour at Çayağzı takes about four hours.

Although a whole group of islands in the area is referred to as Kekova, the name is more properly applied to the largest of the islands. Aşırlı Island, the second largest of the islands in the National Park, is famous for the largest and most interesting pirate cave in the region.

The channel between Kekova and Aşırlı leads into an inner harbour. The remains of the ancient city of Simena along the northern shore of the island of Kekova on the left are submerged beneath the waters. According to geologists, the tectonic activity which raised the level of the Taurus Mts. resulted in a lowering of the level of this particular area.

The remains of the ancient city on the slopes of the island present a very interesting appearance, with ruins of houses, defence walls, drainage systems, water conduits, a bath and flights of steps.

Ancient wharves can be seen here and there several metres below the level of the water and, as on all the other shores

A view of Kekova from Simena Castle (Kaleköy).

89

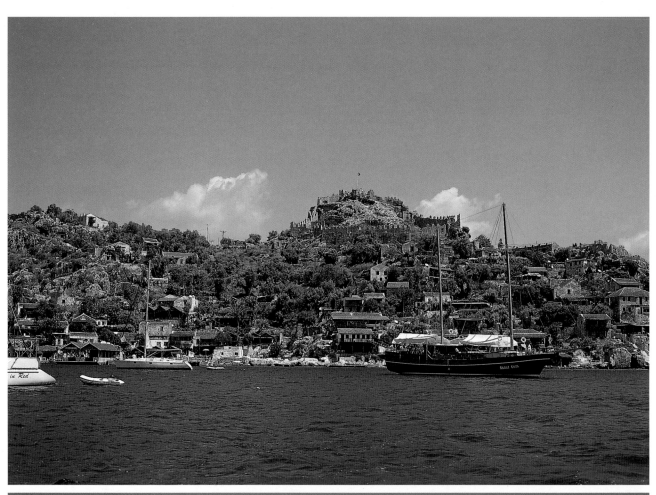

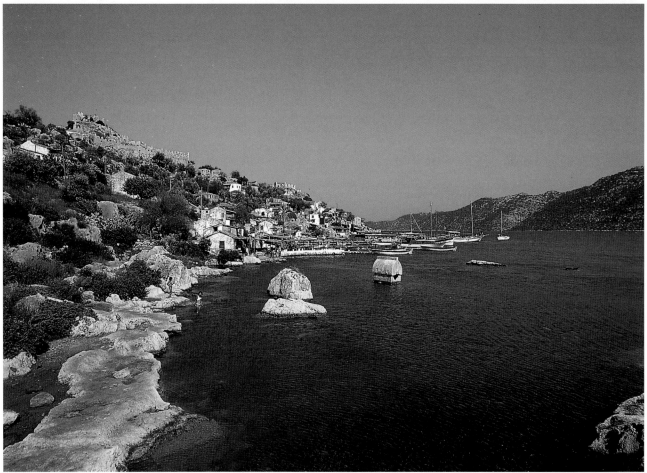

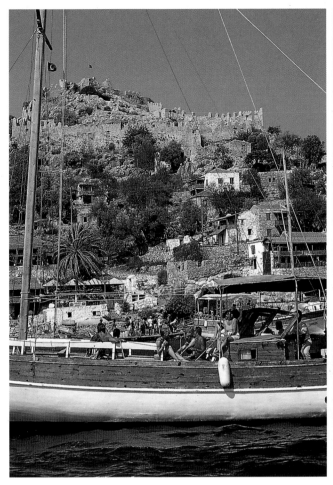

Two typical views of Simena (Kaleköy).

Views from Simena.

p.92-93: Views from Simena and Batıkkent at the Kekova Island, Monastery Bay.

of south-west Anatolia, the waters are extraordinarily clean and pure, with the result that every detail of the ruins is clearly visible at a depth of many metres. The lovely limpid turquoise colour of the water is extremely tempting, but, as it is an archaeological site, bathing, swimming and diving are strictly forbidden. However, you will be offered the opportunity of a dip during the swimming break that will later be given on reaching Tersane Koyu (Dockyard Bay), the furthest point on the trip along the Kekova shores.

The ancient remains at the back of the bay as well as the apse of a church constructed in Byzantine times but later destroyed by an earthquake are also of interest.

On the return trip, we leave the shores of Kekova island and make our way towards a village on the mainland known as "Kaleköy", or "castle village", on account of the impressive ruins to be seen there.

Until recently, a small, rather impoverished fishing village, Kale is now a thriving tourist centre with very fine fish restaurants and pensions. As you approach the village and the environment emerges in greater detail you will find yourselves plunging ever deeper into the depths of the past.

No visitor can fail to be fascinated by the sight of the Lycian sarcophagi scattered amidst the fisher houses or of the Lycian sarcophagus standing in the shallow waters of the sea, which has now been chosen as the emblem of the Kekova National Park.

The ancient city of Simena, founded in the 5th century B.C. on both the mainland and the island, was an important commercial centre. Offering a

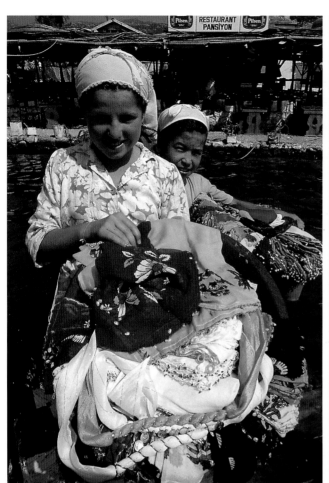

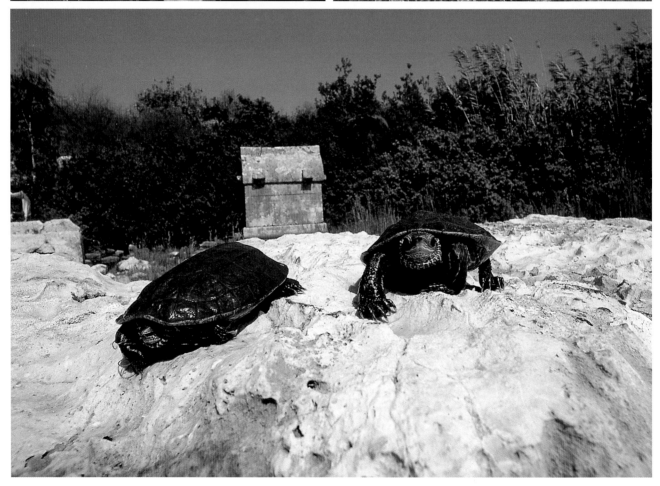

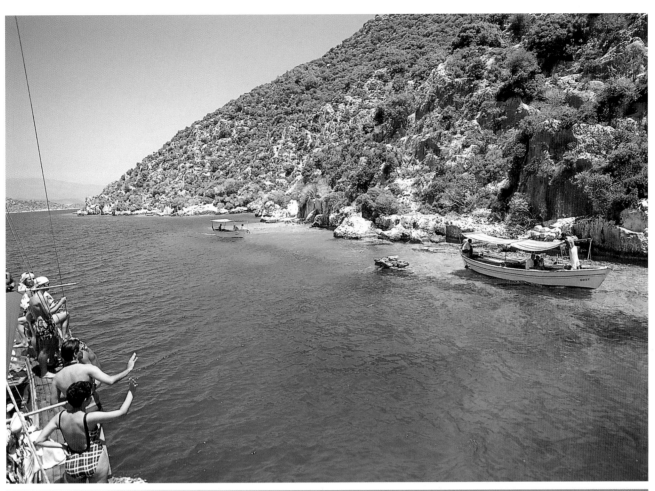

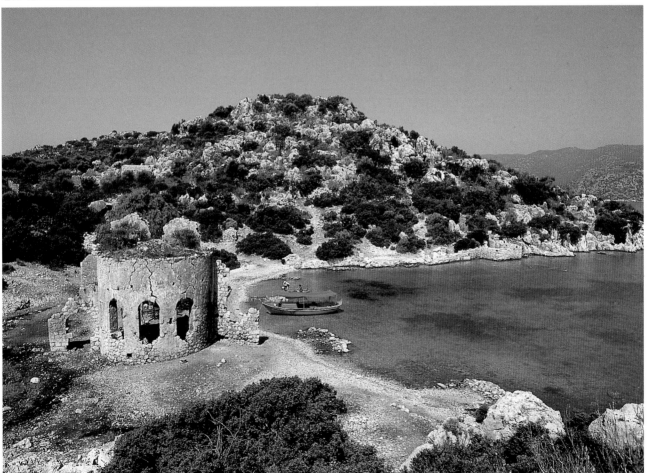

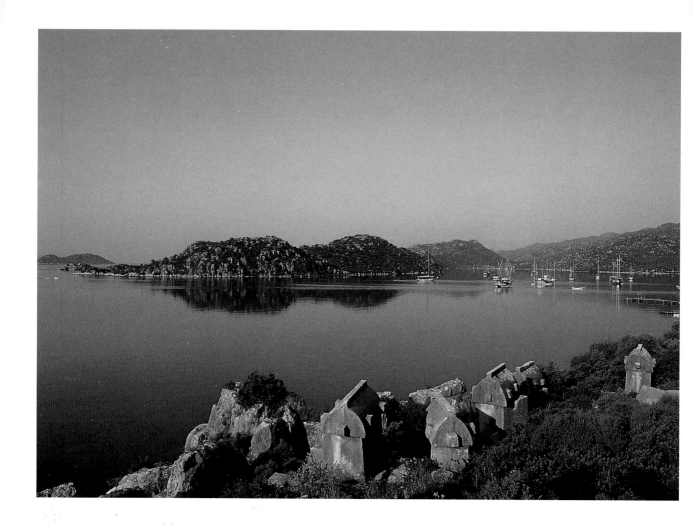

sheltered harbour even in the most violent storms, Simena was one of the stopping-places most highly favoured by mariners.

A path winding along between the fisher houses and the Lycian sarcophagi leads up to the old castle, from which one can enjoy a marvellous view of the truly spell-binding landscape formed by the bay and the islands.

Inside the castle there is a very interesting little theatre with the cavea hollowed out of the natural rock.

With only seven tiers of seats and a seating capacity for no more than 150 spectators it is one of the smallest specimens of its kind. The castle also contains a cistern, a number of rock tombs and the remains of a place of worship.

Towards the east, in the area outside the defence walls, lies the necropolis of the ancient city of Simena, which is also clearly visible from the sea. Some fifteen sarcophagus-type tombs still remain *in situ,* with lion figures clearly visible on some of the lids.

Unfortunately, the sides of all these tombs have been smashed by robbers. It was the custom, in accordance with ancient religious beliefs, to place coins of electrum, a mixture of silver and gold, in the mouths of the deceased, and great damage has been caused in all the necropolises by robbers intent on stealing these coins and other valuable burial gifts.

The distinguishing characteristic of a Lycian tomb is its resemblance to an up-turned boat.

Some explain the shape of the tombs by the desire of the Lycians, a nation of mariners, to use their tombs as boats in the life after the grave.

Panoramic view off Theimussa (Üçağız).

ÜÇAĞIZ - TEIMEIUSSA

After rounding the little islands to the west of Kaleköy and passing through the shallow, rocky channel to the north, we enter a hidden bay that must be reckoned one of nature's veritable masterpieces. The tiny village of Üçağız contains only a mosque and a few houses.

The site was once occupied by the ancient city of **Teimeiussa**, which was founded about the same time as Simena and went through much the same history. The foundations of a large temple and an ancient bath are still visible.

The necropolis on the shore to the east of the village composed of sarcophagus-tombs is one of the finest of its type. Rock tombs can also be seen hollowed out of the nearby cliffs. The necropolis bears witness to the profound philosophical significance of death in Lycian culture.

A half hour's walk from the western end of the bay, an ideal mooring place for yachts even in winter, will take you to the ruins of **Aperlae,** one of the largest of the Roman settlements in the Kekova area.

Here one can still see the remains of the city defence walls, tombs and a number of public buildings.

The village of Üçağız, an important yacht marina, is connected to Finike by 30 km of good asphalt road. From the crossroads a 20 km road will take you to Kaş (Antiphellus).

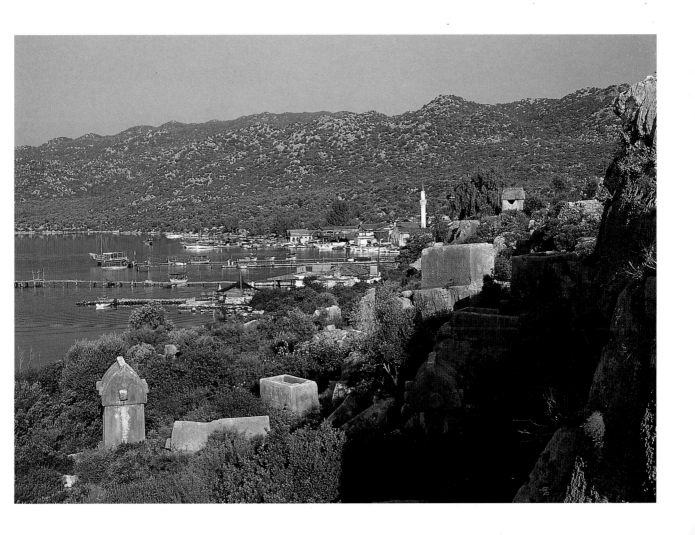

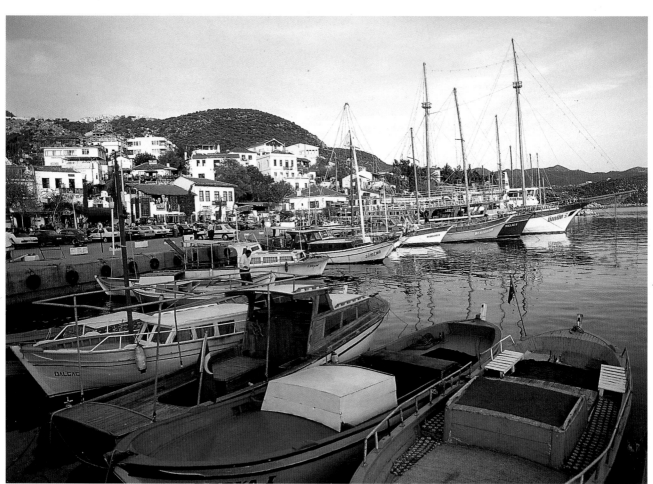

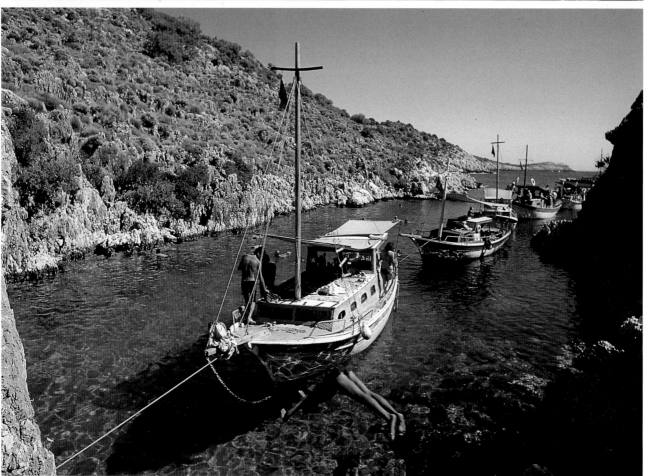

KAŞ and KALKAN

Whether you arrive from the direction of Antalya, travelling from east to west, or whether you do the exact opposite and travel east from Fethiye, there are many visits of a rather arduous but very interesting nature awaiting you. If you travel to west, you will make your way through Xanthos, Letoon and Patara, if to east, through Kekova, Teimeiussa and Myra.

But before embarking on your visits to these places, each more interesting than the other, it might be well to take a short rest, have a delicious fish meal or swim in the clear blue waters of the Mediterranean. For that you have two possible choices: Kaş or Kalkan.

KAŞ-ANTIPHELLUS

Here you will find yet another charming little place of quite extraordinary beauty. Kaş! Stop here for a meal, or at least a cup of coffee or tea. If you do, you may well change your mind and stay for several days. For those familiar with Kaş there would be nothing surprising in that.

On one of a series of bends in a road that goes winding along through the mountains and forests you will quite suddenly and totally unexpectedly see the little town of Kaş down there in front of you in the midst of a vast Mediterranean landscape. From here you can take a marvellous photograph of Kaş with innumerable islands in the background, the largest of them all being Meis Adası immediately opposite the little town. This is the nearest Turkish island to Greece.

Kaş, a view of the port.
Yağlıca bay near Kaş.
A typical view of Kaş.
Kaş, a monumental Lycian sarcophagus in the city.
A typical village at the plateau of Kaş: Bread making women.

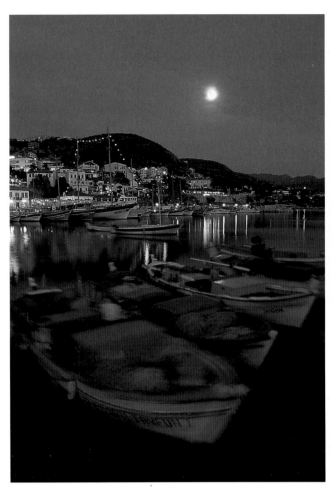

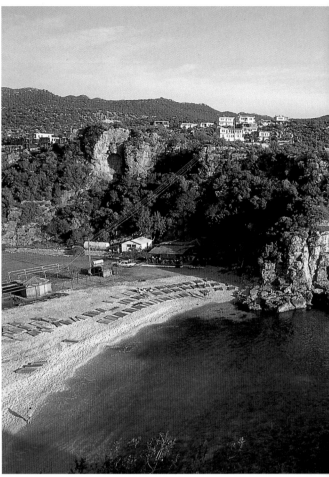

The large bay to the east of Kaş is known as "Liman Ağzı" or "Harbour Mouth". To the west lies the large peninsula known as "Çukurbağ".

The bay with the lovely beaches to the west of the peninsula is known as "Bucak Denizi".

The ancient settlement that once occupied the site, most of which is now buried under the modern town, was first known as "Habessos", and it was by this local Lycian name that the historian Pliny referred to the city, but in written documents of the later Hellenistic period it appears as "Antiphellus", possibly because of its location opposite the ancient city of "Phellus" on the slopes of the mountains about 7 km to the north. "Phellus" itself means "rocky place", so "Antiphellus" might be interpreted as meaning "opposite the rocky place".

Its favourable location, with sheltered harbours opening on to the Mediterranean, made Kaş an important centre of maritime trade. Although earning considerable wealth from the export of olive oil and timber, the lack of an agricultural hinterland and the very restricted supply of drinking water formed an obstacle to any great development of the city, which always remained quite small.

On the right hand side of the road leading from the centre of the town towards the Çukurbağ peninsula you will see a small theatre in the Hellenistic style displaying very fine stone workmanship and in a very good state of preservation. It had a seating capacity of about 3,000.

To the north-east of the theatre lies a tomb of very great artistic significance. There are Doric columns on each side of the entrance leading into the burial chamber, while the dynamism displayed

A spectacular night view of Kaş.

Kaş, Büyükçakıl beach.

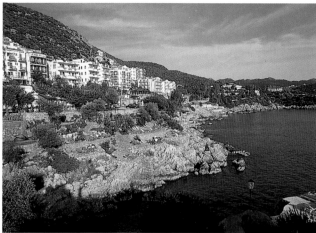

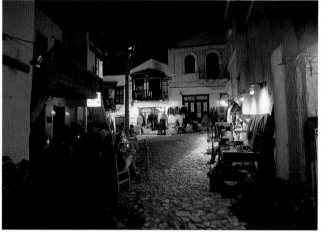

in the movement of the girls depicted in the reliefs and the folds of their dresses shows a level of plastic art far superior to that of its time.

The bench for the deceased is surrounded by a decoration of sea-shells. These features all point to a date in the 4th century B.C.

In the centre of the little town of Kaş you will find a street lined with Turkish houses with bay windows displaying the typical features of old Ottoman domestic architecture.

Making your way between the rows of souvenir and gift shops, cafés and bars that line the street you will arrive at the very impressive sarcopgaus tomb that Kaş has adopted as its emblem.

The whole sarcophagus, along with its podium, is hollowed out of a single piece of rock, and on one side of this Lycian sarcopahagus, which, like the tomb in the vicinity of the theatre, dates from the 4th century B.C., can be seen an eight-line inscription in the Lycian language.

The lion heads on each side of the lid symbolise the warlike character of the occupant of the tomb while at the same time serving as handles with which to raise the lid.

Interesting sarcaophagi and rock tombs can be found in the various side-streets, by the side of the harbour and on the outskirts of the town.

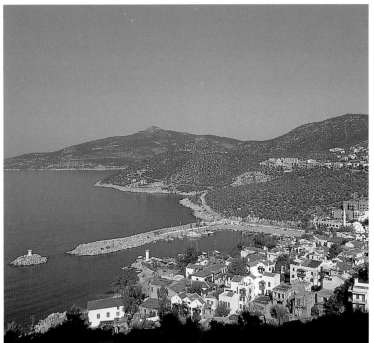

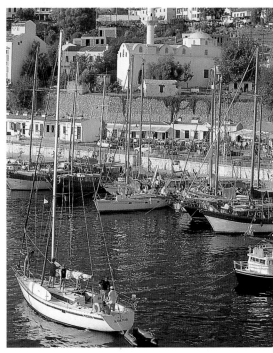

KALKAN

Kalkan is located 27 km to the west of Kaş. Until recently a small fishing village, the extraordinary beauty of its situation on the shores of the Mediterranean and the exemplary hospitality of its inhabitants have transformed it into one of the most important and rapidly developing tourist centres in the region.

There was no ancient settlement on the site so there are no ancient remains to be seen, but it is a very charming little town with very fine examples of old Ottoman domestic architecture dating from the end of the 19th and the beginning of the 20th century. The little town, with its labyrinth of shops and stalls selling souvenirs and touristic goods, its charming little cafés, bars and pensions, is an ideal stopping-place for the visitor arriving either by road or by yacht at its small marina. Unfortunately, like almost all the other towns and villages on the Mediterranean coast, Kalkan is under threat from the inevitable

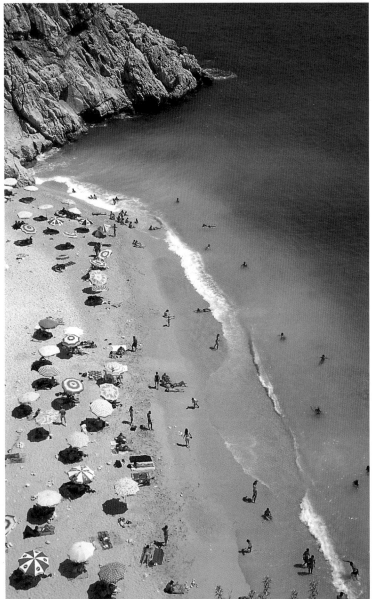

Kalkan, panoramic view.

Kalkan, Yacht - Marina.

Kalkan, Kaputaş beach.

encroachment on both sides of large hotels and housing developments, covering the area with a modern concrete construction that clashes violently with the natural beauty of its surroundings.

XANTHOS-KINIK

The foundation of the ancient city of Xanthos dates back to as early as the 2nd millennium B.C. According to Strabo, the distinguished ancient traveller and geographer, the name "Xanthos", derived from the river, now known as the Esen Çayı, on whose banks it stood, had the meaning "yellow" in the Hellenic tongue. In the Iliad, Homer mentions a warrior from Xanthos by the name of "Sarpedon" who fought by the side of the Trojans against the attacks of the Achaeans. According to Herodotus, the city preserved its independence until the Persian invasion in the 6th century B.C.

One of the most striking incidents in the whole history of the city occurred when the citizens of the city, realising that their defeat by the Persian army under its commander Harpagus was inevitable, returned to Xanthos and, collecting their wives and children in the acropolis, set fire to the city, leaving their

Xanthos Amphitheater.

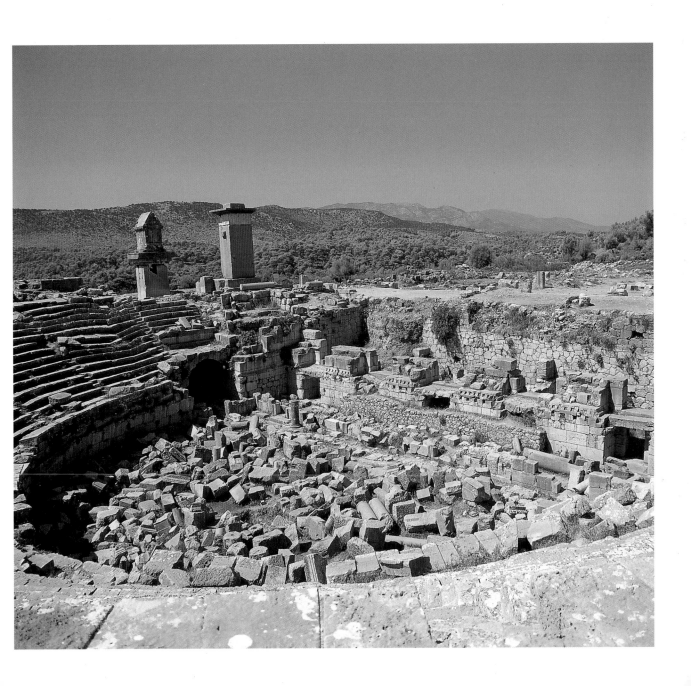

families to perish in the flames.

Later, about 70-80 families who escaped this mass slaughter joined some other migrants in re-founding the city, which was, however, completely destroyed by a devastating conflagration in the second half of the 5th century. Destroyed by Brutus in 42 B.C. in retaliation for its mutiny against Rome, it was rebuilt by Antony one year later. After this, the city steadily grew in wealth and importance, and was adorned with a large number of very fine monuments. Later, during the Byzantine period, large basilica was built here.

With the arrival of the Turks, the city fell into complete oblivion until the archaeological remains were brought to world notice by the British explorer Fellows in the course of the 19th century.

On entering the city, you will immediately be struck by a group of Hellenistic remains. On the left hand side of the road there is an agora surrounded in ancient times by a very fine portico, an ancient theatre, the Harpy monument and the inscribed stone. Although the theatre displays some Hellenistic features it obviously assumed its final form in the Roman period, when the whole was enlarged by the addition of a stage building. On the right hand side, which was used as an acropolis in the Roman period, one can see the remains of an arch dedicated to Vespasian. Immediately beside this there is a heroon (sanctuary) with Ionic columns known as the Nereid Monument, and, a little further on, a Byzantine basilica with very fine floor mosaics.

XANTHOS is particularly famous for its pillar tombs. One of these, known as the Harpy Tomb, is about 9 m in height, and consists of a pillar surmounted by a

Xanthos Amphitheater, Harpies monument.

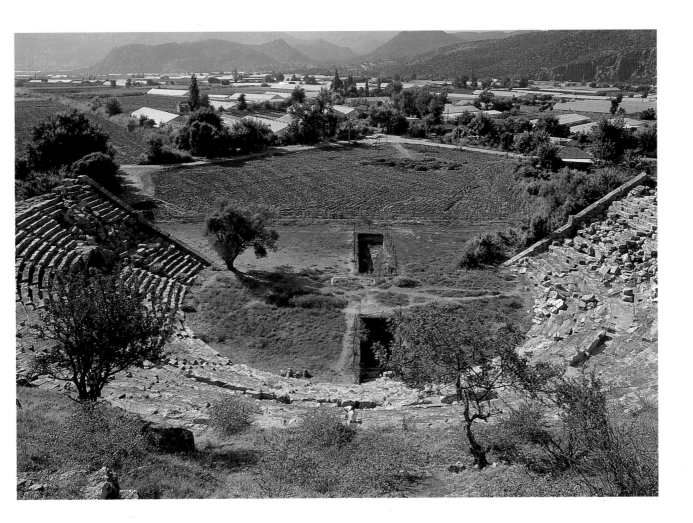

burial chamber adorned with reliefs depicting a king and his consort receiving gifts presented to them by their children and other members of the family.

The style of the reliefs would suggest a date in the first half of the 5th century B.C. The original reliefs, which were carried off by the British and are now preserved in the British Museum, have been replaced by plaster casts.

The pillar tomb immediately beside this is surmounted by a Lycian sarcophagus in the form of an upturned boat in the Lycian tradition. This would appear to signify "Life passes by like a ship that is finally overturned by death".

The stele erected to the north of the agora was dedicated to the Xanthian warrior-hero Kherei. On the four sides of the stele there is a 200 line inscription in the Lycian language and a 12-line poem in Greek.

LETOON

Situated at a distance of 4 km from Xanthos, Letoon was a sanctuary belonging to the Lycian League. It derives its name from the mother of Apollo and Artemis.

According to a myth related by the Roman poet Ovid, Leto was made pregnant by Zeus, and then, after giving birth to Apollo and Artemis on Delos, arrived at the point where the Xanthos river flows into the sea, whence she made her way up to the spring. Here she attempted to bathe her children but was prevented from doing so by the local inhabitants, who feared that the spring would be polluted and, furious at this, Leto took her revenge by transforming the whole population into frogs.

The spot was subsequently adopted

by the Lycian cities as a sanctuary devoted to the cult of the three divinities.

Passing the ancient theatre, the visitor arrives at a site located in a pool of stagnant water.

It would appear that here too, as at Kekova, tectonic activity resulted in the lowering of the ground level. The ruins themselves stand on a comparatively high mound which raises them above the level of the water.

The site contains three temples, two in the Ionic order and the third in the Doric, the two larger temples, dedicated to Leto and Artemis, being in the Ionic style, and the smallest, which contains a floor mosaic dating from the Hellenistic period, being in the Doric. Other remains include a very fine nymphaeum or monumental fountain, a Byzantine monastery and an ancient theatre, which has not yet been fully excavated.

Letoon. Artemis Temple.

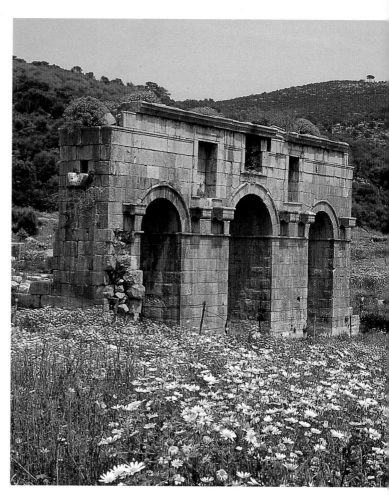

P A T A R A

Patara is a small but very beautiful site on an extraordinarily beautiful beach of clean, fine sand. It was the port of Xanthos during the period of that city's independence, and subsequently grew to be the most important port in Lycia, becoming the administrative seat of a provincial governor during the Roman period. Famed as the birthplace of St Nicholas (Santa Claus), it contained an oracle of Apollo which, according to the sources, functioned only during the winter months.

On the left hand side of the road as one enters the site there is a triple-arched triumphal gate, and, immediately beside this, a few Lycian type tombs. Also on the right, a little further on, can be seen the remains of a Roman bath and a

Patara, Monumental city gate.

The unique beaches of Patara.

Patara Theather.

Visiters on horseback at the beaches of Patara.

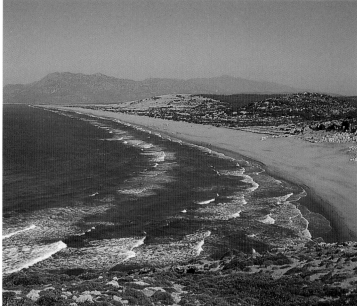

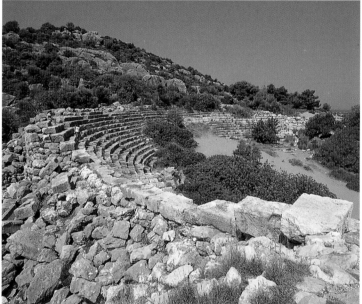

Byzantine basilica. Proceeding in the direction of the theatre and making your way past a bath complex dating from the reign of the Emperor Vespasian, you will arrive at the ruins of a small Corinthian temple located on a small mound.

The ancient theatre is in a comparatively good state of preservation but is partially covered with sand. On the rocky hill against which the theatre is built stand the remains of a temple of uncertain dedication, and from here you can enjoy a very extensive view of the whole archaeological site. If you look very carefully in the direction of the old harbour you will be able to see, about a kilometre away, granary buildings dating from the reign of Hadrian.

FETHIYE

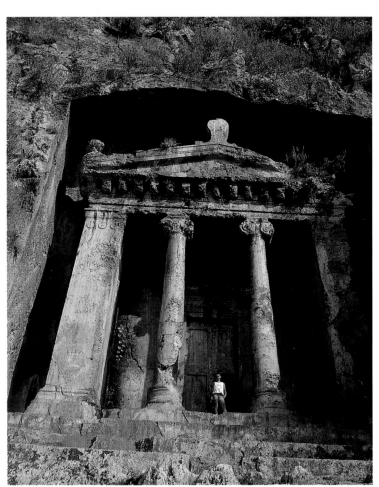

One of the loveliest coastal cities in Turkey and one of the most highly developed tourist centres, Fethiye is surrounded by mountains behind and a lace-like coast of quite extraordinary beauty in front. If you have time, you are strongly advised to hire a boat and take a sail through the islands scattered here and there in the vicinity. Fethiye, known in ancient times as Telmessos and one of the gates to the province of Lycia, forms the centre of an area rich in interesting sights and uniquely lovely beauty-spots.

The ancient historians describe Telmessus as having been a settlement of some importance during the Lycian period and mention the existence of a

Fethiye (Telmessos), The monumental tomb of king Amyntas.

Fethiye, panoramic view.

Fethiye, amphitheater.

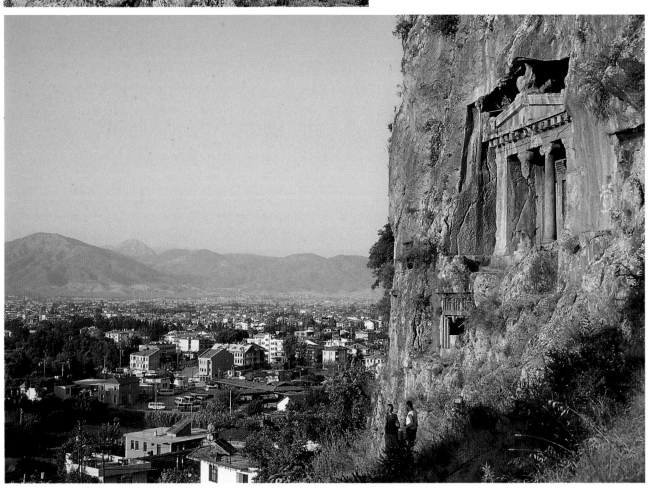

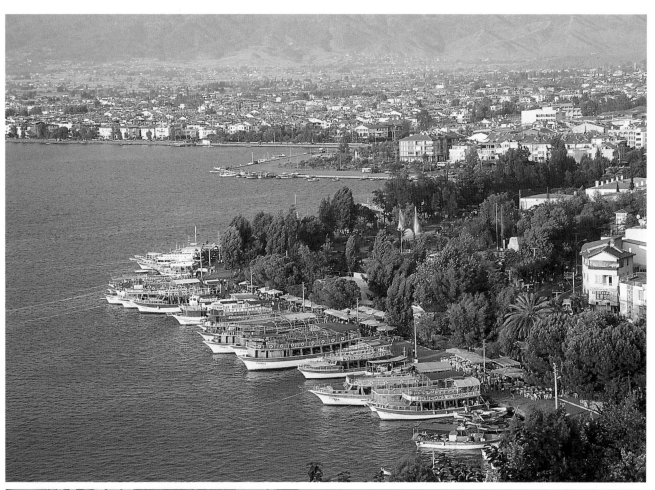

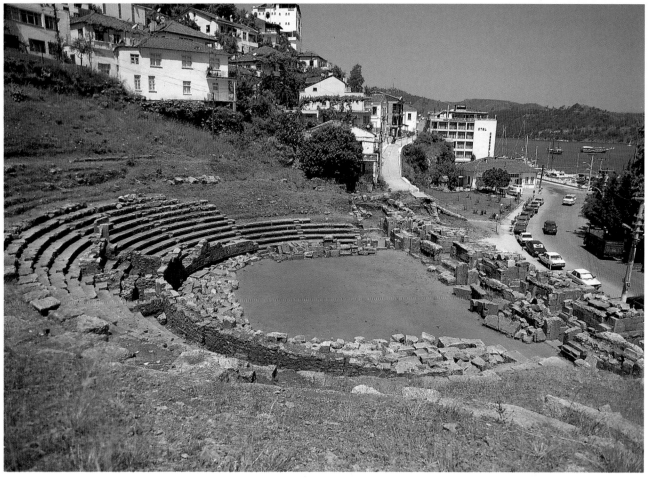

temple dedicated to Kakasbos, a horseman-deity who has been identified with Heracles. Unfortunately, no trace of such temple has been discovered. Undoubtedly the most important of the ancient monuments is the "Tomb of Amyntas", the famous Lycian rock-tomb dating back to the 4th century B.C. situated on the eastern slopes of the city. A steep flight of steps leads up to the entrance, which, with its two Corinthian columns hewn out of the rock, is very clearly visible from quite a distance. The inner chamber is in the form of a family tomb.

On the slopes of the hill can still be seen the defence walls and fortification towers of the Byzantine castle located on the summit, from which one can enjoy an extraordinarily beautiful panoramic view over Karaköy. The path leading to the ancient necropolis passes a number of rock tombs hollowed out of the slopes. A sarcophagus tomb of quite exceptiopnal beauty can be seen immediately adjacent to the Town Hall.

Ölüdeniz, indisputably one of the loveliest beaches in the world, lies only a short distance away and must definitely be seen by any visitor to the Fethiye area.

Ölüdeniz, a unique view.

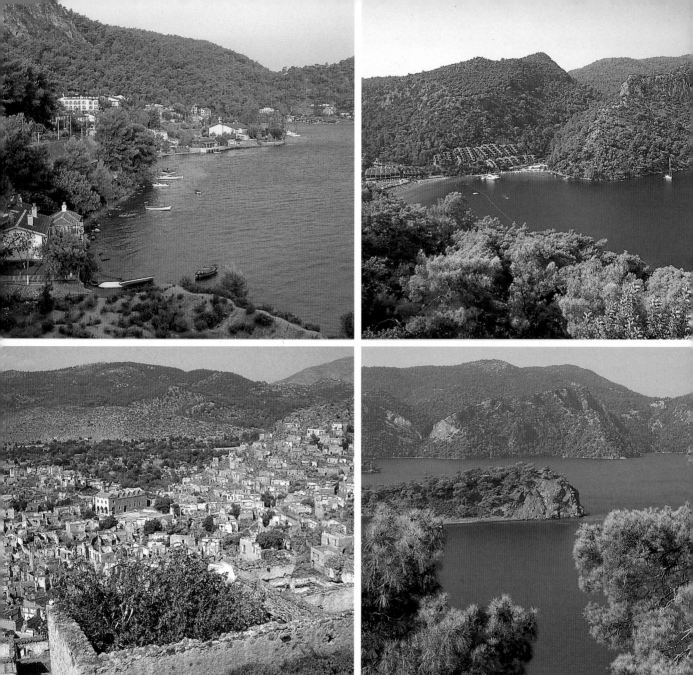

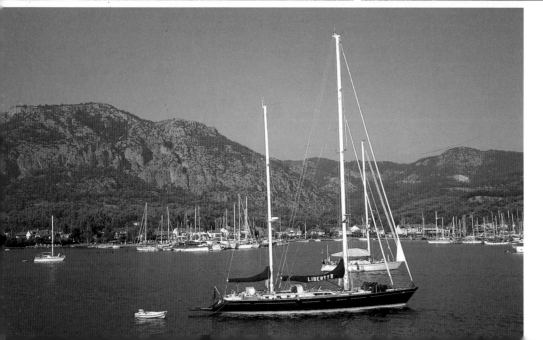

Views of the bays of Fethiye.

General view of Kayaköy.

The port of Göcek

The canyon of Saklıkent.

Pınara, Theather.

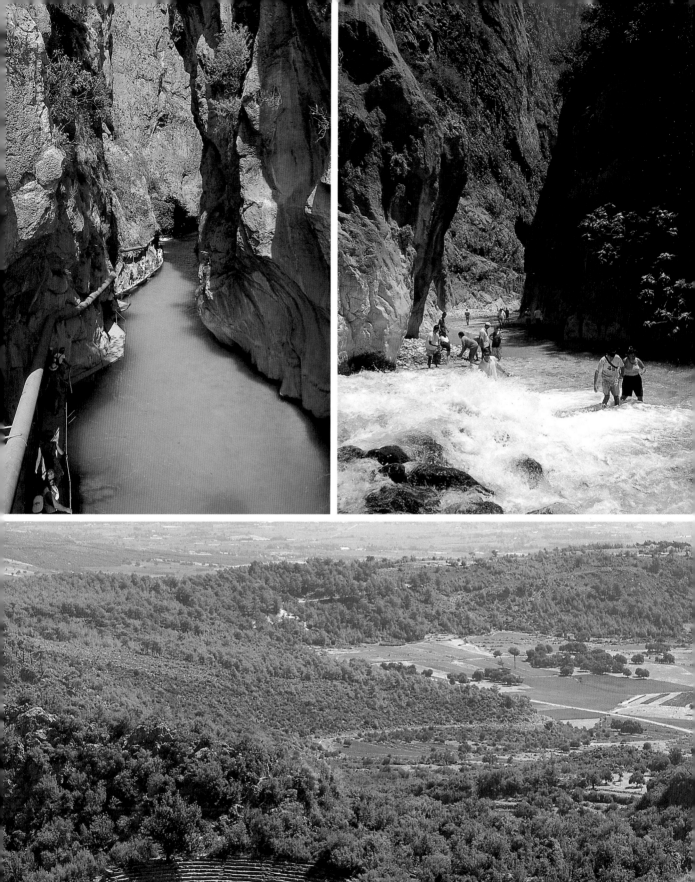

REVAK

ANTALYA
TURKEY'S SOUTHERN COAST

CONTENTS